IMAGES

of America

ABINGTON

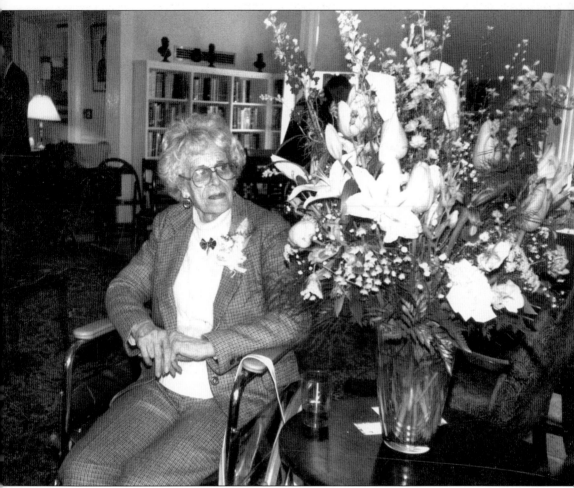

This book is dedicated to Martha Campbell, Abington's town historian. She is shown here in a photograph taken by Donald Cann at her 90th birthday party, which was held at the Dyer Memorial Library in 1997. After moving to Abington in 1955, she began a lifetime of dedication to researching and educating others in the history of Abington. She was a founding member of the Abington Historical Commission, curator and historian for the Historical Society of Old Abington, and a noted author of numerous historical works.

Martha Campbell made Abington's history come alive. Even today, the spirit of her work inspires both young and old to explore the roots of Abington's rich history.

Thank you, Martha, for making this book a possibility.

IMAGES
of America

ABINGTON

Sharon Orcutt Peters

ARCADIA

First printed in 2002.
Reprinted in 2003.

Published by Arcadia Publishing,
an imprint of Tempus Publishing, Inc.
2A Cumberland Street
Charleston, SC 29401

Printed in Great Britain.

Library of Congress Catalog Card Number: 2002102512

For all general information contact Arcadia Publishing at:
Telephone 843-853-2070
Fax 843-853-0044
E-Mail sales@arcadiapublishing.com

For customer service and orders:
Toll-Free 1-888-313-2665

Visit us on the internet at http://www.arcadiapublishing.com

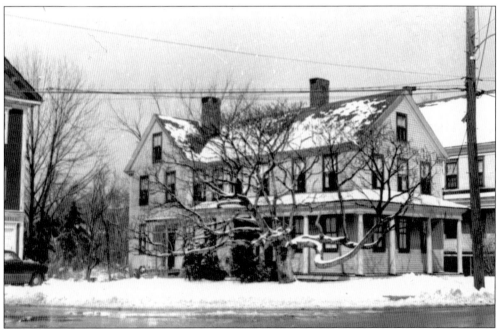

The tree at the intersection of Brockton Avenue and Washington Street became a landmark of Abington Center. Its branches bowed down to time, and the tree was finally cut level to the ground. To many Abingtonians, it will always be the place where the tree used to be.

CONTENTS

ACKNOWLEDGMENTS

This book was created because the people of Abington take pride in their history. Many thanks to all who contributed to this worthwhile project. When word got out that the book was under way, without hesitation you took your prize photographs off the wall, frame and all. You enthusiastically shared your memories and encouraged others to do the same. Whenever the name of this book is mentioned in the future, the portrait I will see will begin and end with you.

Robyn Fernald, chairperson of the Abington Historical Commission, rolled up her sleeves and dug into the task at hand. Her vision, knowledge of history, and commitment to the commission is always an inspiration. In her tenure of the last 15 years, there were times that she alone kept the doors of the commission open. I am grateful to her that the door was open wide enough to let me pass through. I am honored to serve my town as a member of the Abington Historical Commission.

The Dyer Memorial Library has an outstanding collection of historical research and memorabilia. Joice Himawan, its director, and Pam Whiting not only opened their doors, they enthusiastically opened every cabinet within the Dyer's walls. Special thanks to Pam. Her interest, attention to detail, and curiosity make her one of the treasures to be found at the Dyer.

Nancy Reid was an incredible resource, not only through her position at our public library but as an Abingtonian who shares her knowledge of the town. Nancy gave of her photographs and innumerable stories. On more than one occasion, she willingly walked away with a to-do list.

Kate Kelley is a legacy in the town of Abington, and I am honored to share a page with her. For nearly three decades, she has written about those most special people who make our town what it is today. She is a historian in her own right, and her lifetime of work gives magical insight into the town and its people.

Special thanks to my mother, Patricia Orcutt-Peters, and my brother Tom for their help in creating the layout of the book. Thanks also to my little cousin Rachel; her love of Island Grove is an inspiration.

Photographs, information, and guidance were also provided by Jim Griffin, Albert and Elizabeth Beal, Malcolm Whiting, Alfred Balentine, Theresea Minehan, Dori Jamieson, Hugh Cox and his son Bill, Pamela Whittall-Rice, Fred Villa, Wayne Rogiers, Mary Graham, Barbara Lindholm, Mary Dalton, Kevin Donovan, Dean Sargent, Doug Ulwick, Jean Lothrup, Michael and Shiela Travi, Leola Jobert, Pat McKenna, Mary Rourke, Hank Cahill, Lisa Curtin, Ken Coyle, Jim and Jane Doughty, Bruce Fernald, Bob Baker, Walter Pulsifer III, Joe Penney, Terry Tedeschi, Shawn Cotter, Mel and Ruth Libby, Richard Donovan, Chief Richard Franey, Mary and John Valatka, Harris Damon, Hon. Martha Ware, Meredith "Rip" Ripley, Karen Wood at Kay Printing, the staff at PhotoQuick in Quincy, the staff at the Abington Public Library (who helped collect photographs), and Debbie Sullivan of the Weymouth Historical Society.

Because of your efforts, you have helped to preserve our history for future generations.

INTRODUCTION

In a deal known as the Bridgewater Purchase, the area now called Abington was sold by Massasoit to Myles Standish. At that time, land grants divided Bridgewater into shares and settlements. Abington was born of this region, known to the Native Americans as the "land of beaver." The area was more vast in those times and included the towns that we know today as Whitman and Rockland. We are told that two rivers, as well as numerous brooks and streams, drifted through open forests of white oak and groves of pine.

In 1668, Andrew Ford was the first to make his settlement. His acreage is thought to have stretched from the boundary of North Abington to the center of Abington.

Lumbering became the foremost trade of the original Abington settlers. By the early 1700s, mills had been erected to manufacture wood for the growing shipbuilding trade in Scituate, Hingham, and Weymouth. In this way, Abington wale planks came to be a part of the USS *Constitution*. Some of the boards from these old Abington trees still support the floors and attics of Abington houses.

In those days, Abington had only two popular routes of travel. According to Benjamin Hobart's *History of the Town of Abington* (1866), the first road was said to stem from Middleborough, through East Bridgewater, down Washington Street, and into Weymouth (Route 18). The second road came from Plymouth, through Hanson, into Abington via Plymouth Street, and continued on to Weymouth (Route 58). Journeymen would then find their way to Boston from these towns, a trip that would take days. In addition to these roads, there were many cart paths and cut-throughs. One such path was a route from South Weymouth's Great Pond area, which was already a formidable location of mills and settlements. Settlers coming from Weymouth, including our own Andrew Ford, built some of Abington's oldest houses.

The Massachusetts Bay Colony was still under the direction of England, and posts and land grants were doled out. Anne Bertie, England's Countess of Abingdon and daughter of the Earl of Abingdon I, was said to have been instrumental in naming Gov. Joseph Dudley to his post. In appreciation for her help, the governor named the town of Abington for the countess. In 1712, it became incorporated.

By 1732, the town of Old Abington had its first schoolhouse. In addition, Andrew Ford's meadow had been dammed and flooded to create a millpond for growing industry.

The early 1800s brought the weaving trade. In 1845, the Old Colony Railroad was started. Irish settlers began to make their homes in Abington at this time. The population of Old Abington is thought to have been about 5,200 residents. It was sometime in the first half of the 1800s that the shoe industry began to take root. The railroad, successful industry, and the growing population created the need for a bank. In 1850, the Abington Bank was first incorporated.

While Abington was certainly earning a reputation for its success as an industrial town, the town had already become known as the location for some of the greatest speaking engagements of the time. Island Grove hosted some of the nation's best-known abolitionists. In William Lloyd Garrison's newspaper the *Liberator* (1831–1865), the "Beautiful Grove" is mentioned no

fewer than 50 times. We lent both our soldiers and our land to the cause of liberating slaves. After the Civil War, Abington was where soldiers were mustered out. In 1870, eight citizens of this area called themselves "Musterfield" residents.

The town began to develop regional strengths, and it would soon be divided, Rockland and Whitman taking their independence. In 1874, East Abington became Rockland. The following year, the area known as South Abington was made a township; it was renamed Whitman. West Abington had become known for its farms. North Abington was being shaped by the railroad and shoe industry, and Abington Center was characterized by the mills and industries surrounding Island Grove. Soon, the growing, independent town of Abington flourished with restaurants, hotels, and merchants.

As Abington approached the end of the 1800s, the railroad and railway companies became increasingly important for employees as a means of travel to the growing number of shoe companies in Abington. From 1844 to 1893, the Old Colony Railroad had served Abington well. In 1893, the railroad was taken over by the New York, New Haven, and Hartford Railroad. In its desire to cut costs, the new company made a decision not to allow additional streetcar tracks to cross the railroad line. The town of Abington had already granted permission to the Abington & Rockland streetcar line to lay tracks along North Avenue. The dispute created the North Abington Riot. The North Abington Depot was built shortly thereafter and is said to have been built as a peace offering by the railroad. The depot was the first Abington landmark to be named to the prestigious National Register of Historic Places.

Abington had always taken great pride in its history. The 1912 bicentennial celebration offered a dedication of the park to those Abington soldiers who had fought in the battles of our country. The Memorial Bridge, the arch, and the commemorative boulder mark the reverence that Abingtonians felt toward their neighbors who had fought in both the Revolutionary and Civil Wars.

By the mid-1900s, the Great Depression and two world wars had once again shaped the image of Abington. Many of the shoe companies moved north, and imports became popular.

There is little doubt that the town of Abington has had a rich history. Remnants of the shoe industry and mills are testimony to our industrialism. So much pride do we take in our community and its history that to this day we have a custom of assigning our town name to those we love—Mayor, Lady, or Mother of Abington. Throughout the town's nearly 300 years, its longest-lasting monument has been its people. They are truly the heart and soul of Abington.

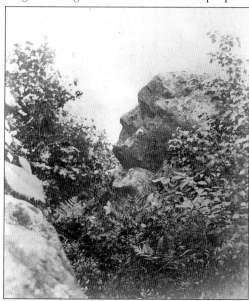

Chiseled by nature, the boulder known as Lady Abington was once located on Bedford Street. Unfortunately, the boulder was destroyed in the early 1920s to make way for new roads.

One
ABINGTON CENTER

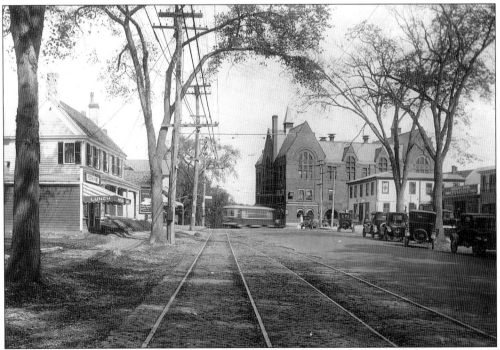

Abington Center is pictured c. 1938 in a view looking north. The Abington Savings Bank building can be seen in the distance on the right, once located where Abington Liquors stands today. Also on the right is Angeley Brothers Firestone Tires and Tubes. Finn's Luncheonette is across the street. The trolley car is making its way toward Whitman.

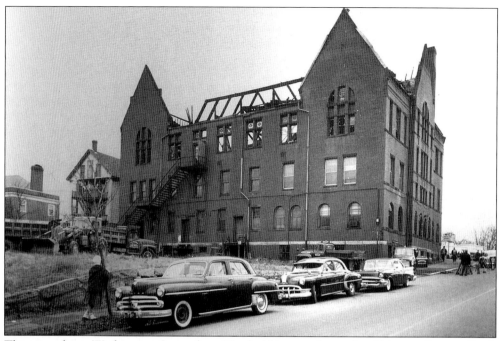

This view down Washington Street from North Abington shows the Abington Savings Bank after it burned on Saturday, November 26, 1960. The fire began around 9:00 p.m. and eventually destroyed the bank. The Dyer Memorial Library building is to the far left.

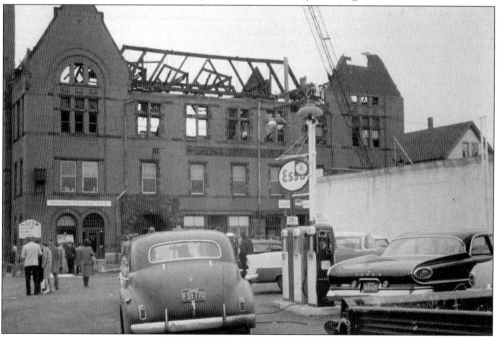

The burned-out Abington Savings Bank building is shown in a view from Whitman on Washington Street. The photograph was taken from the Esso gas station parking lot, where the Abington Savings Bank drive-through is now located. One can see the sign marked Route 123 at the intersection.

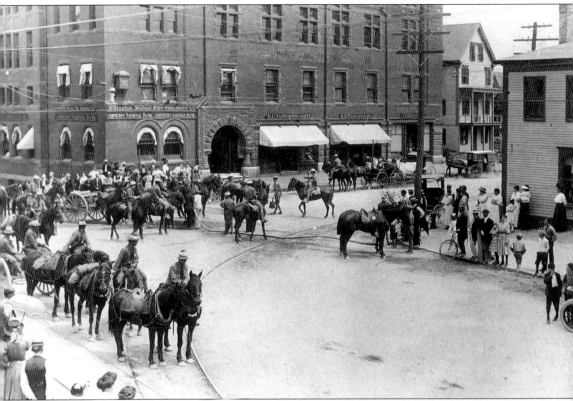

This 1909 photograph shows the Abington Savings Bank block when war games stopped in Abington Center to water the horses. War games were Civil War reenactments staged by veterans across the region.

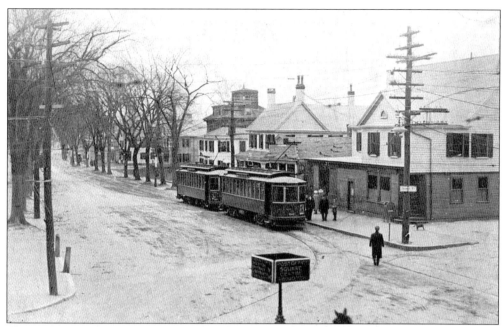

This early-1900s photograph shows Post Office Square in Abington Center. Note the sign in the middle of the square. The location of Erickson's store, the post office, and the butcher shop (operated by Hank Oliver) is now the site of Abington Dry Cleaners.

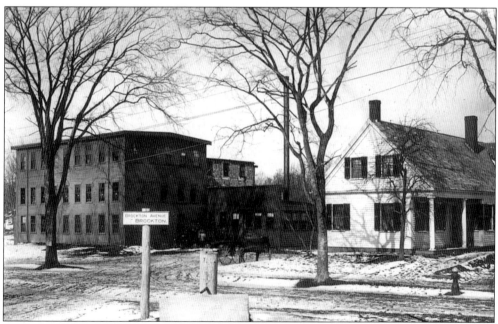

William O'Brien's Heel Factory stood at the junction of Brockton Avenue and Groveland Street, which is near the present-day Dunkin' Donuts. During the thriving shoe industry days, it was common to have entire companies built just to manufacturer one part of the shoe. The heel factory's location on Brockton Avenue was ideal for reaching both Abington and Brockton manufacturers.

Annie M. Leavitt was the postmistress in the Abington Center Post Office, located at the corner of Orange and Washington Streets. Leavitt Terrace, located across from the present-day high school, is named in her honor. The photograph was taken *c.* 1900.

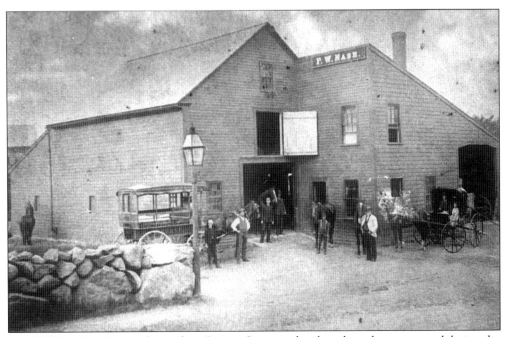

The F.W. Nash stable was located on Orange Street and is thought to have operated during the late 1800s. An advertisement for the stable reads, "Livery, Sale and Boarding Stable—A fine set of teams always ready. Teams with careful drivers to any part of the country."

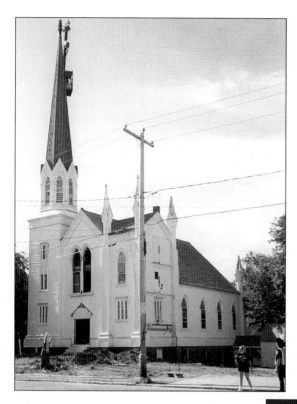

The Glad Tidings Assembly of God Church was originally known as the First Society of New Jerusalem in Abington. The church, which dates from 1833–1834, was the only church edifice in Abington to retain its original spire and was mentioned in Benjamin Hobart's book *History of the Town of Abington*. Demolition took place on July 7, 1998, and the land was purchased by Abington Savings Bank for its new drive-through.

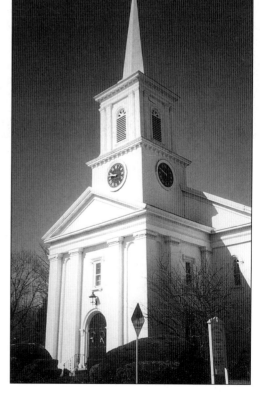

Pictured is the United Church of Christ, located on Meetinghouse Hill. The building stands on the approximate site of the first meetinghouse, the location of which appears on Abington's oldest map, which was drawn by Dea. Daniel Shaw in 1796. The present-day church was built in 1849.

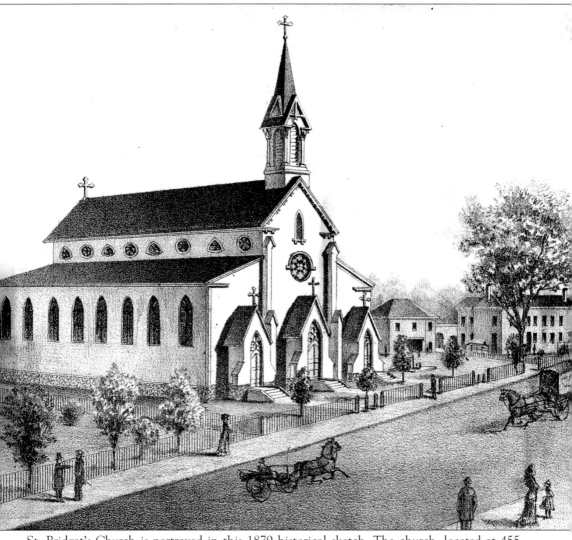

St. Bridget's Church is portrayed in this 1879 historical sketch. The church, located at 455 Plymouth Street, is the oldest wooden Catholic building on the South Shore.

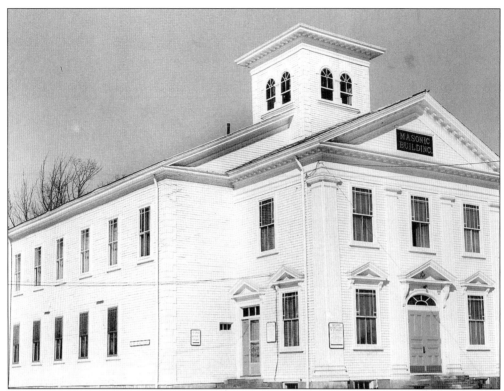

The Masonic building was erected in 1819 and stands at 416 Washington Street. Timber from neighboring shipbuilders were found in the attic of the building, along with timber from the razed "blue church," which had been across the street. The blue church was built after the first meetinghouse was torn down. This third church was used for only 30 years before the United Church of Christ was built in 1849.

Best known as the Grange Hall, the Grand Army of the Republic hall was built in 1896. The building, which is at the corner of Washington and Central Streets, is recognized for its unique cupola.

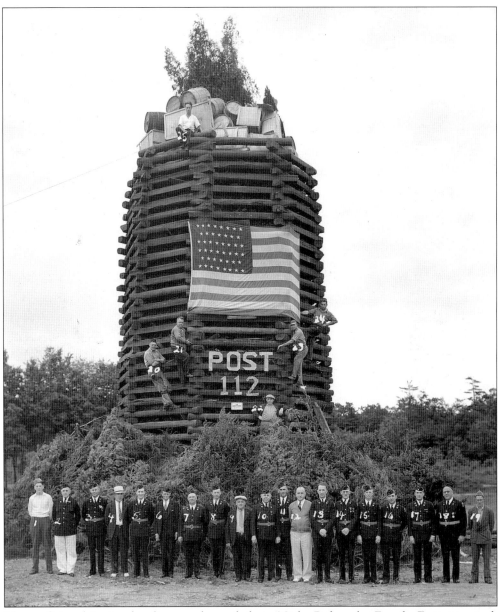

The traditional Legion bonfire was the prelude to Night Before the Fourth. Festivities took place behind the Frolio school, near the little brook that runs through the playground. This photograph of the 1925–1926 pyre reads, "Ready for setting off!"

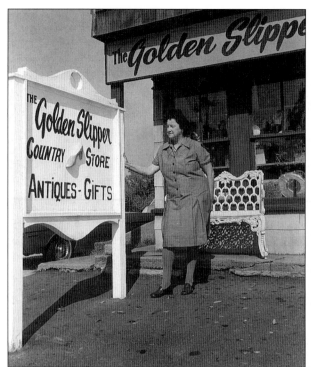

The Golden Slipper operated in at least three different buildings at the intersection of Washington Street and Center Avenue in Abington Center. Malcolm Whiting, fire chief, fondly remembers stepping inside the building on slanted floors. He also recalls the dazzling jars of treats that were on display at the Golden Slipper.

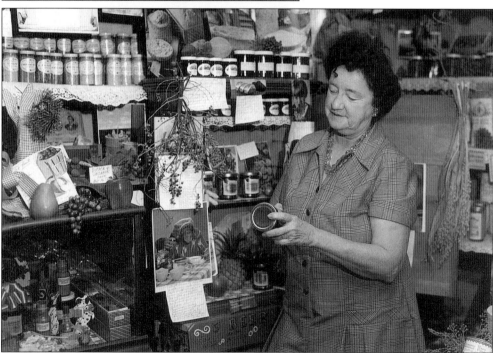

Lucille Lindholm operated the Golden Slipper—an antique, candy, and novelty shop at 18 Centre Avenue—from 1947 until the late 1970s. She grew to be a legend in Abington, especially among the many children who admired her displays of candy, and came to be known as "the mother of Abington."

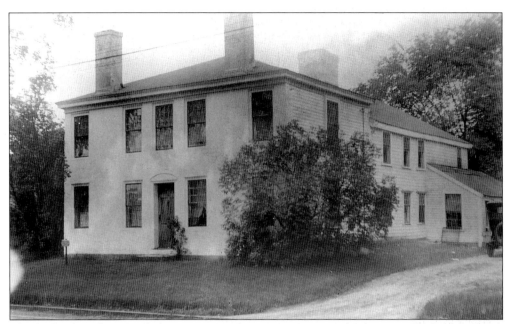

The back of Andrew Ford's house, on Washington Street, was built in 1735, while the brick front was an 1804 edition. Ens. Andrew Ford (1682–1750) was the son of Andrew Ford, the founder of Abington.

Inventory records state that Cyrus Nash's house was built in 1850. However, some portions of the house may actually be older. Cyrus Nash, the town's first historian, was born in this house on Centre Avenue in 1780.

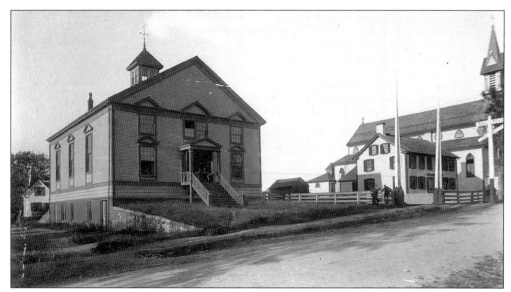

Lyceum Hall, also known as the "old town hall," was located along Centre Avenue, adjacent to where the railroad tracks are now and were then. The photograph shows St. Bridget's Church on the opposite side of the tracks.

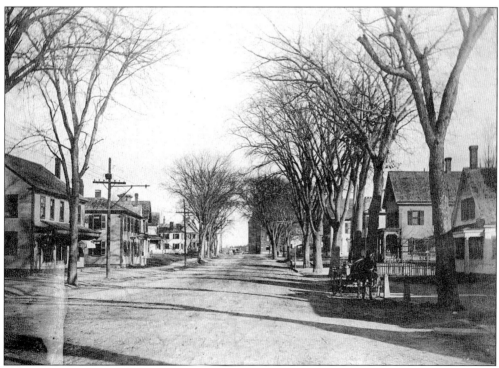

This view from Washington Street shows Post Office Square in Abington Center. The photograph is thought to have been taken in the early 1900s.

Two
NORTH ABINGTON

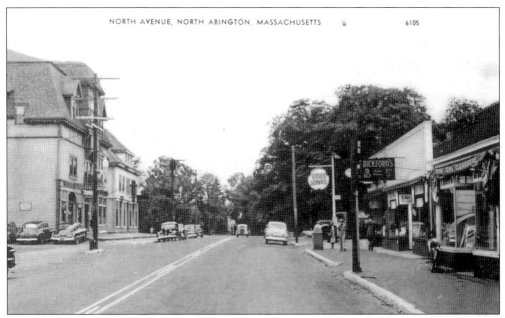

NORTH AVENUE, NORTH ABINGTON, MASSACHUSETTS 6105

This postcard photograph from the 1940s or 1950s shows a view down North Avenue. Bickford's restaurant is clearly noticeable on the right side of the street. On the left, the Standish and Winthrop buildings largely make up what was referred to as the Standish Block.

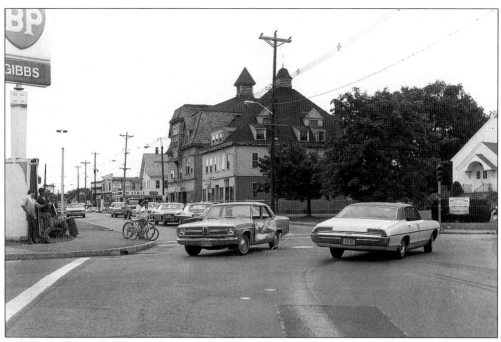

This early-1970s photograph shows the Standish Block in North Abington Center. The cupola marks the Standish building. Adjacent is the Winthrop, which recently burned down.

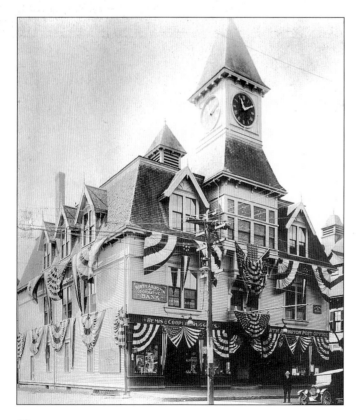

The Standish building was the location of the North Abington Cooperative Bank, Bemis Drug, and the North Abington Post Office. In this c. 1912 photograph, the building is decorated with patriotic colors in honor of the 1912 bicentennial celebration.

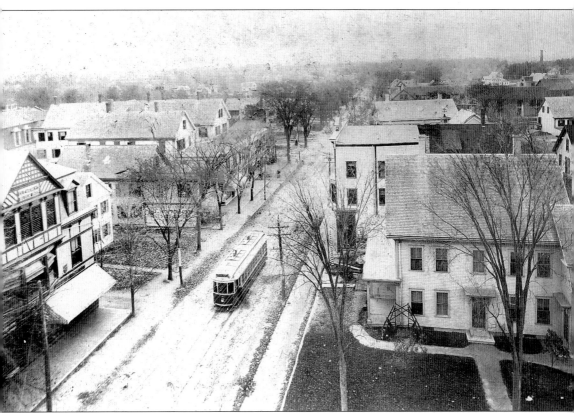

This c. 1912 view from the Standish building shows a time period when streetcars made their way through North Abington. It was said that the clanging noise of the passing streetcars frightened the horses. The Abington & Rockland streetcar line was in service until c. 1935.

Kate Kelley recalls, "The Capital Theatre, on Railroad Street, provided entertainment for a half century. It was small compared to city movie theaters but brought Hollywood to Abington for a small admission price that included a newsreel, cartoons, and two movies. The theater hosted a dish night to lure customers and Saturday and Sunday matinees. It closed when television sets became a household item, but the screen is still in the building."

The Capital Theatre building was constructed in 1894 by Henry Crossley. The building was used by Crossley for a shop that specialized in sleighs, harnesses, and fine horses, but it also sold household items. In 1915–1916, it was sold to the Peerless Theatre. During the mid-1900s, it became the Atlantic Card Company. Remnants of the painted signage are still visible on the building today.

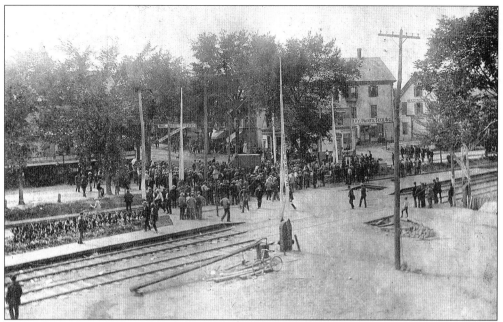

This photograph is one of the few taken of the 1893 North Abington Riot, which took place along North Avenue and Railroad Street. The riot occurred after the New York, New Haven, and Hartford Railroad voted against requests for streetcar tracks to cross their rights-of-way. The town of Abington voted that they were vital. As the line was being laid down, a brawl broke out.

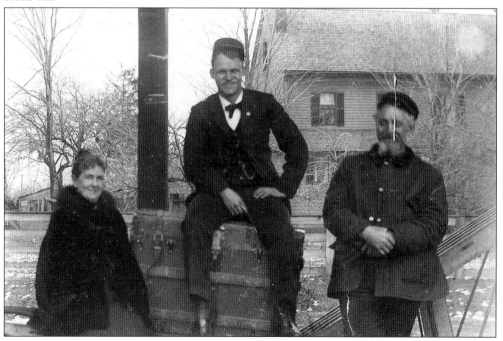

Pictured in the early 1900s at the Abington Station of the Old Colony Railroad are, from left to right, Faustina L. Carey, telegraph operator; Percy R. Shaw, station agent and baggage man; and Levi B. Sampson, crossing tender and freight agent.

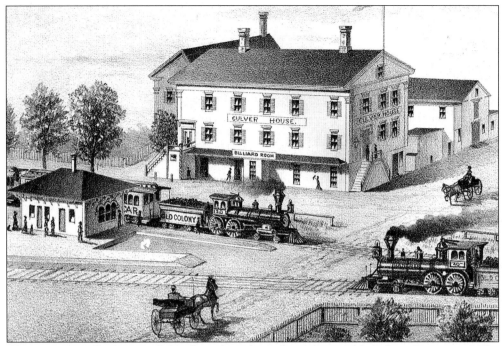

The caption on this historical sketch reads, "The Culver House, J.M. Culver, Proprietor." The *c.* 1879 sketch includes the railway of the Old Colony Railroad. During the 1893 riot, protesters are said to have thrown obstacles at the rioters from the second-floor windows of the Culver House. Many might recognize this building as the present-day location of the Cellar.

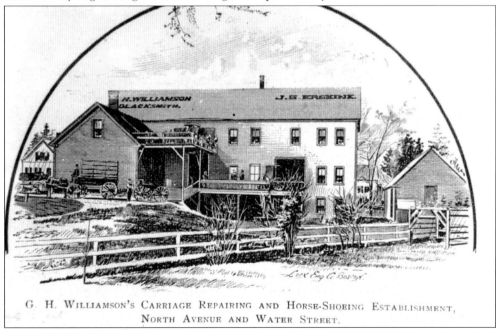

G. H. WILLIAMSON'S CARRIAGE REPAIRING AND HORSE-SHOEING ESTABLISHMENT, NORTH AVENUE AND WATER STREET.

George H. Williamson moved to Abington from Marshfield *c.* 1885. He took up residence at 55 Wales Street and set up his own blacksmith shop *c.* 1890. In 1925, the property was sold to the Polish Club, and changes were made to the building.

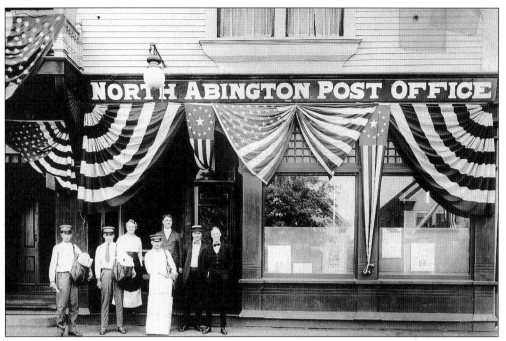

The North Abington Post Office was located in the Standish building at the intersection of North Avenue and Plymouth Street. The building is decorated for the 1912 celebration.

The Baptist church, built in 1887, stands at 231 Adams Street. The church's most distinctive feature is its rubble-stone entrance. The clock tower of the Standish building can be seen from this Plymouth Street view.

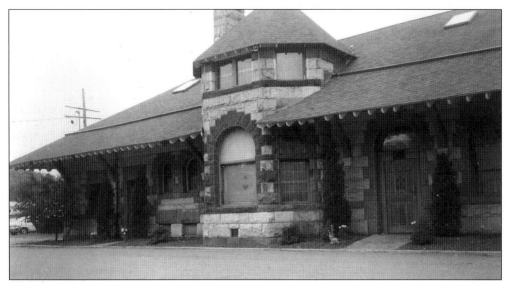

The North Abington Depot, built in 1893–1894, has granite walls and a brownstone base. It was designed by Bradford Lee Gilbert, a highly regarded architect. The railroad company erected the depot after the North Abington Riot. Today, the building is the location of a popular Abington restaurant.

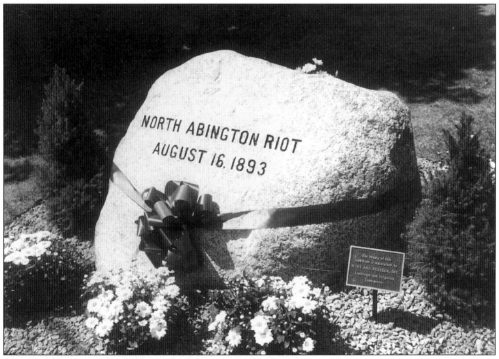

This boulder was placed in Arnold Park on Railroad Street to commemorate the North Abington Riot, which took place in 1893. The dedication ceremony was held at the reenactment of the riot, organized by the Abington Historical Commission on August 15, 1993.

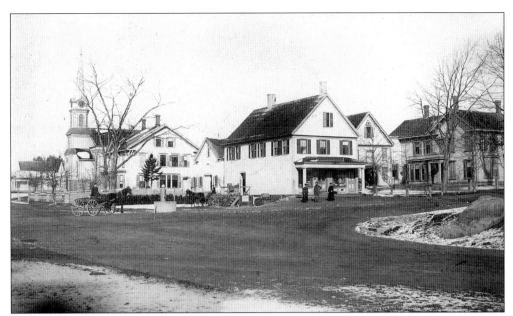

Pictured in 1880 is Harwood's Corner, the intersection of Route 139 (Randolph Street) and Route 18 (Bedford Street). The church in the distance is the former Fourth Congregational Church. The store located at this intersection was Kals, owned by the Kalinowski family. Note that the road is unpaved but cleared of trees. The store burned down in the early 1970s.

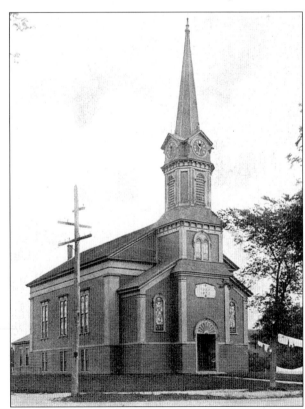

The Fourth Congregational Church, located at 33 Randolph Street, is shown in 1890. The church was built in 1839. The Sunday school wing was added in 1956. Beginning in 1972, the building housed Abington's town offices and the public library. The former church was converted to Meetinghouse Corner Apartments in 2000.

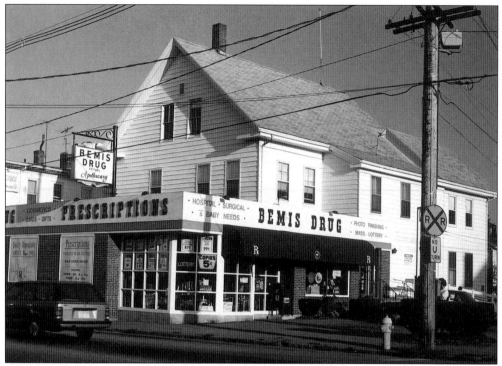

Open for business on North Avenue since 1905, Bemis Drug was originally located in the Standish building, where the church parking lot is now.

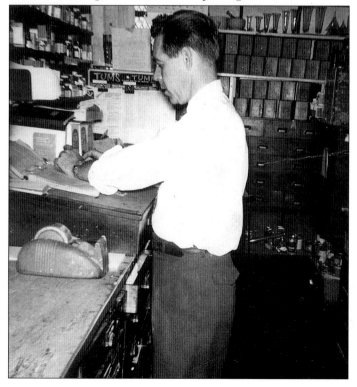

Pictured in 1960, Hugh Cox was pharmacist and owner of Bemis Drug. Cox explains that in the old drugstore, all labels on prescription drugs were written by hand.

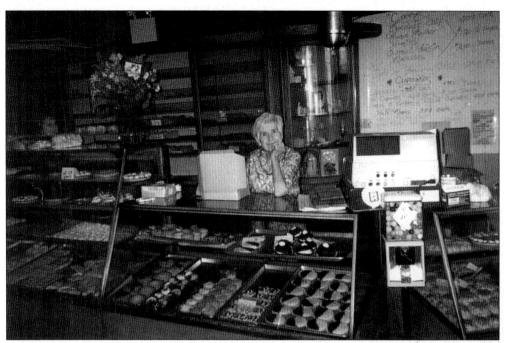

Martin's Bakery has been in business for more than 50 years. The Villa family bought the restaurant from Mr. Martin, who was already operating a successful bakery. Fred Villa insists that the only caption fitting for this nostalgic photograph of Ma Villa is "Where everybody knows your name."

MARTINS BAKERY & RESTAURANT
HOME OF MA VILLA

FOR OVER 50 YEARS
205 NORTH AVE ABINGTON, MA 02351
RTE. 139 TEL: (781) 878-1915
HOME COOKED BREAKFAST & LUNCH

Martin's Bakery gift certificates are available in $10 denominations. Ma Villa has become somewhat of a town celebrity. Fred Villa carries on the 50-year family tradition of restaurateur.

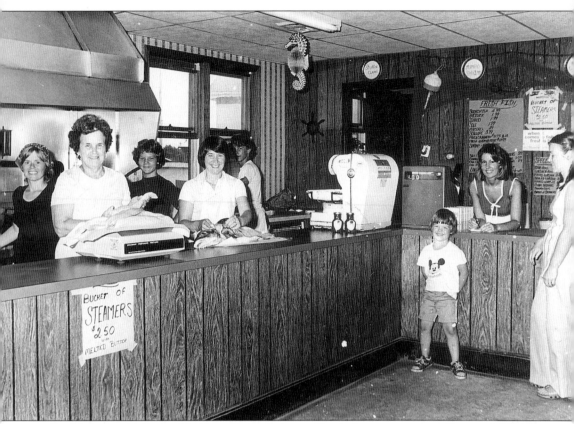

Established in 1944, the Old Town Fish Market on North Avenue is pictured here in 1976. The fish market is now known as Bowser's and operates on Bedford Street. Pictured from left to right are Edna Little, Mabel Bowser, Mark Nugent, Barbara Lindahl, David Lindahl, Brian Doherty, Diane Bowser, and Jean Bowser.

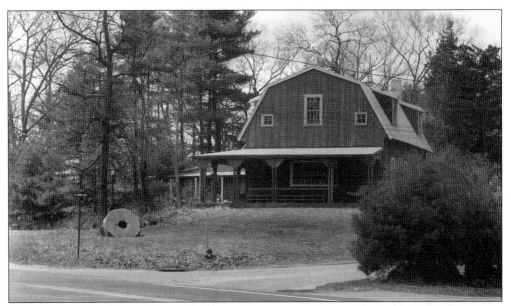

The Olde Abington Country Store has been open for business at 1148 Bedford Street since December 2001. Lisa Curtin, granddaughter to Everett Slayter, and her husband, John, have a wonderful store that celebrates history and the life of Slayter, who collected interesting items over the years. A wheelwright's stone sits in front of the store.

Taken from Lisa Curtin's family album, this photograph shows Everett and Lillian Slayter c. 1945. Everett Slayter built the structure himself, using wood from older demolished buildings around Abington. Some of the floorboards at the store are from the 1700s.

Kate Kelley writes, "Tucked in the northeast corner of Abington is the Musterfield neighborhood. It was here, on the longest stretch of level land between Boston and Plymouth, that the state militia practiced and was received by the governor. Streets such as Battery and Camp are testament to the time when the land was used as practice grounds." Mary Sheehan Reardon and her son Louis are pictured at their Musterfield home on Arch Street.

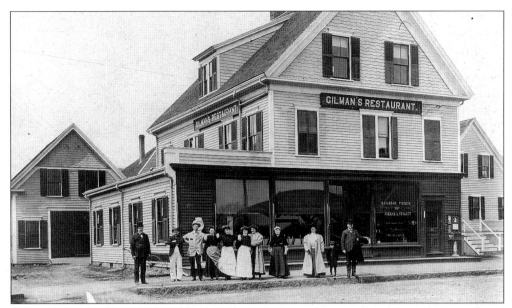

Owned by Caleb D. Gilman, Gilman's Restaurant stood opposite the depot at 94 Railroad Street. It became very popular among residents during the time Eleanor Badger took over the restaurant, from approximately 1904 until 1936. As there were no cafeterias in schools at the time, the principal of the Adams Street School, Charles Frahar, would walk to the restaurant at lunch. It was also a popular lunch place for Arnold shoe factory employees.

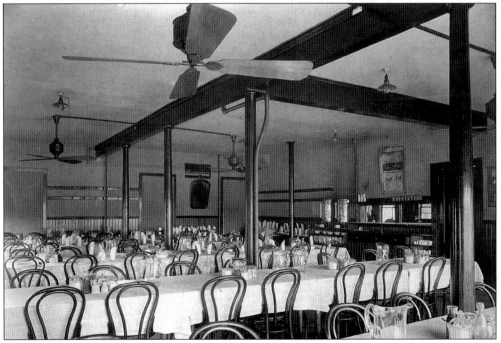

Ellen (Welch-Gould) Brunstrom worked in the restaurant from the time she was in the fifth grade until she was a junior in high school. She had this to say about one of the restaurant's most popular guests: "As far as John L. Sullivan drinking pig's blood, if he did, it wasn't at our restaurant as we never had pigs."

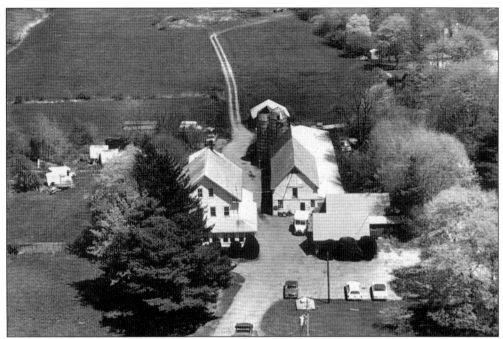

This photograph offers an aerial view of Griffin's Dairy. The Griffin family purchased the farm in 1925–1926. It started out as a dairy farm with chickens, pigs, and cows. In the 1930s, a riding stable was added. The heifer barn (in the back) was built from trees that had fallen during the 1938 hurricane. Many residents have fond memories of having their milk delivered by Griffin's Dairy.

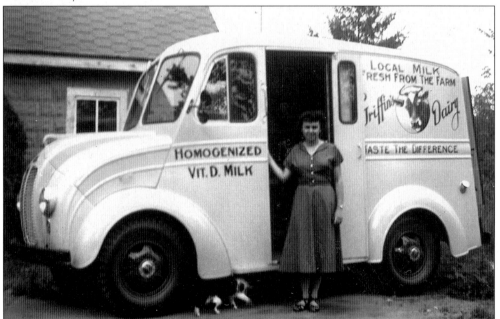

Taken from Jim Griffin's family album, this c. 1940s photograph shows Esther Griffin at the farm. The dairy trucks were painted by a Mr. Orrall. Jim Griffin has a vivid memory of how the cow's eyes seemed to follow you wherever you went.

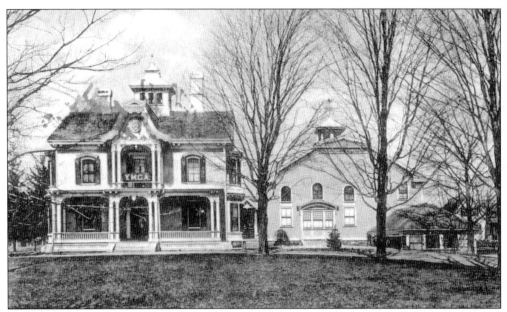

The YMCA was located at 164 North Avenue. Many an Abington youth would balance atop the old stone wall outside the building in the early 1900s. It was a popular place for many children.

The Moses N. Arnold house was built in 1849 at 325 Adams Street, only blocks from Arnold's shoe company on Wales Street. Additions were made in 1893. The house is sprawled out in the center of Abington, but much of the greenery is now gone.

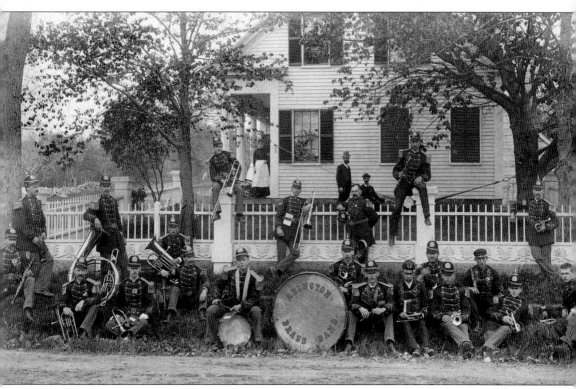

This photograph of the Abington Brass Band was taken *c.* 1880 as the band made its way down Washington Street toward North Abington. Music and community have always been an important part of Abington's identity.

Three
WEST ABINGTON

No image could better symbolize West Abington than that of Albert and Elizabeth Beal. Albert was born on October 28, 1909, and Elizabeth was born on May 18, 1918. Their farm, Sun-Ray-Lea, is an abbreviation for the names of their three children. The farm began in the early 1900s and still offers fresh eggs and produce. Albert Beal has written several stories about early-20th-century life in West Abington.

John L. Sullivan was born on October 12, 1858, and died on February 2, 1918. Even today, his memory is alive and well in Abington, where he eventually retired. Sullivan was known as the "Boston strong boy," and he would ride through the streets in his horse-drawn Irish jaunting cart. Many Abingtonians still talk about the lively days of John L. Sullivan.

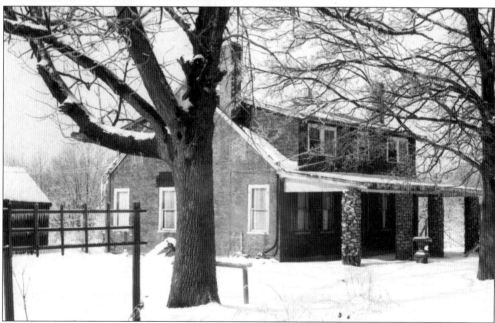

The house at 704 Hancock Street was home to world heavyweight champion John L. Sullivan. Sullivan was best known for his 75-round bare-knuckle fight with Jake Kilrain in Richburg, Massachusetts. The sweat-stained American flag that Sullivan wore around his waist during the fight can be seen at the Dyer Memorial Library. Before Sullivan owned this house (shown c. 1812), it was owned by "Big Brother" Bob Emery, of radio fame.

John L. Sullivan had this rocking chair custom-made *c.* 1912 because of his girth. When Sullivan died in 1916, the chair was given to his next-door neighbor, Tom Conarty. At Tom's death in 1941, the chair came to his daughter, Celia Ashton. It was then presented to the Blue Hill Fox Hunter's Association by Joe and Celia Ashton in 1960.

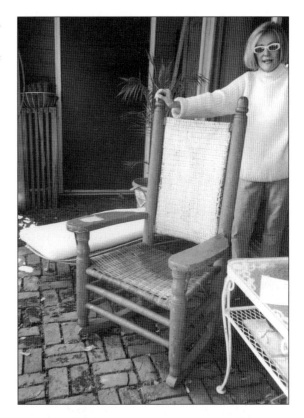

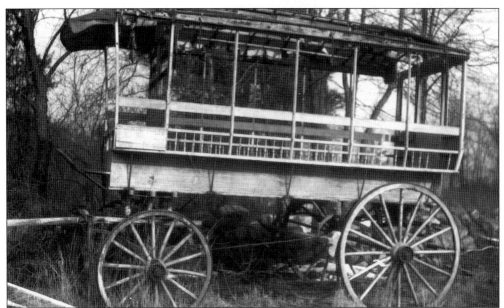

Albert Beal once wrote of Bernie, the driver of the West Abington Stagecoach, "He would let a favorite little girl sit up on his high seat with him. Occasionally, he would have to stop the stage, set the brake, waddle around to the back door, climb the three steps up in the coach, crowd his way forward, and shake the devil out of some kid who just would not behave."

The West Abington Improvement Hall, shown *c.* 1940, was constructed specifically for the West Abington Improvement Association. Today, it is being used by the Girl and Boy Scouts of America.

This church, located on Old Randolph Street, was erected in 1880 on land donated by Joshua and Sarah B. Ford. In its first year, it was the Union Evangelical Church. By 1884, the church was formally organized as the First Methodist Episcopal Church. In 1968, the church became part of the newly incorporated United Church of Christ.

This house, at 852 Hancock Street, was built *c.* 1850. The famous Gustavus Adolphus Somerby's private school was once held in the hall. Martha Ford Arnold, who had grown up in this neighborhood, once wrote of the school, "We are told that in 1842 some of his pupils gave a remarkable performance of one of Shakespeare's plays, which so horrified some of the more serious-minded patrons that it came near bringing the school to an untimely end."

This early-1970s photograph shows the Abington Country Store, located at 852 Hancock Street. The store is most likely the second building erected on this site. The first house here belonged to William Wales and was built in the 1750s.

Located at 1020 Hancock Street, this house was erected by Emerson Orcutt II c. 1830. In 1831, he paid his first year's taxes on its valuation of $100. The house later became the home of the Fitts family. Richard A. Fitts Drive (just southeast of the home) was named for their son, who was missing in action during the Vietnam War.

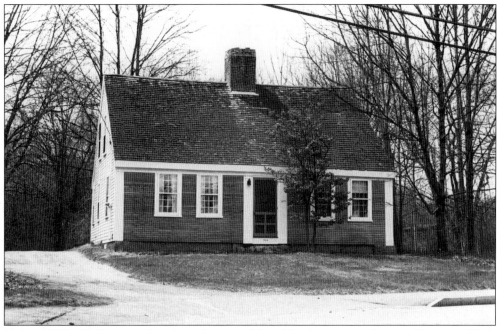

Built c. 1751, this house is thought to be one of the oldest houses standing in Abington. With an address of 500 Randolph Street, it was built on land owned by Emerson Orcutt Sr. In 1762, Orcutt sold part of the land and house to Lt. John Ford, great-grandson of Abington's founder, Andrew Ford. At one time, the house could only be reached from the North Abington settlement by a cart path.

44

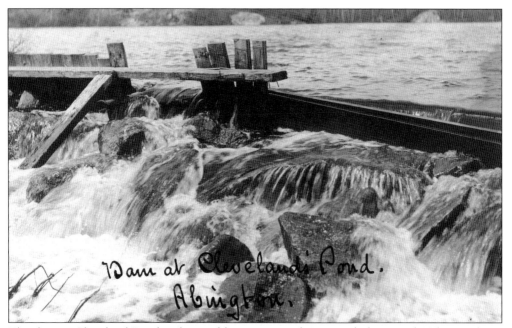

The dam at Cleveland Pond is depicted here in an early postcard photograph. The pond was dammed to create an energy source for the early mills.

Many an Abington youth remembers skating on Cleveland Pond in West Abington, shown here c. 1930–1940. Ice cutting was also done there. The pond has been incorporated into the Ames Nowell State Park.

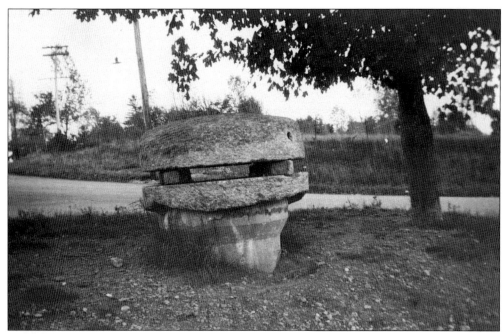

These grindstones are from the gristmill that once belonged to Capt. Edward Cobb, who used them to grind cornmeal sometime in the late 1700s. The millstones were discovered in 1919 by Alton P. Trufant, a surveyor and historical researcher. Today, they are located at the corner of Hancock and Chestnut Streets in West Abington.

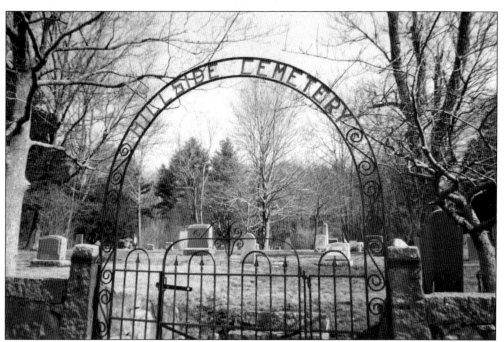

Hillside Cemetery, with its traditional arch at the entrance, is often referred to as the West Abington cemetery. The oldest stone in the cemetery is dated 1796 and is a memorial stone belonging to Capt. Cornelius Dunham's son.

Four
INDUSTRY AND BUSINESS

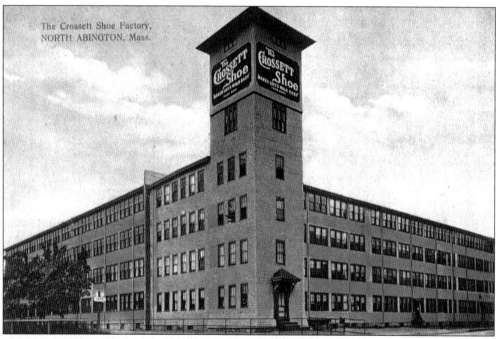

The Crossett Shoe Factory is still a landmark in North Abington. It was built in 1888 by Lewis A. Crossett. Additions were later built to accommodate the growing shoe-manufacturing industry. These additions make for the interesting and distinct shape of the building. About 300 cases of boots and shoes were made here each week. Birchcraft Studios, a division of New England Art Publishers, is now located here.

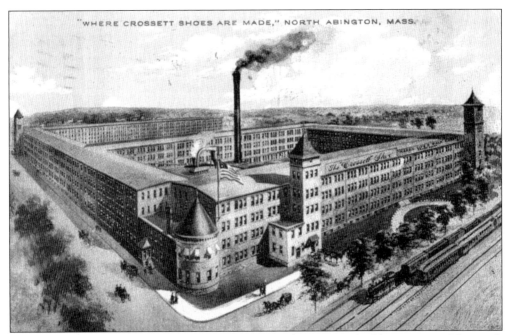

"WHERE CROSSETT SHOES ARE MADE," NORTH ABINGTON, MASS.

During the 1960s and 1970s, portions of the Crossett Shoe Factory building were used for retail. Some mothers may remember venturing up to the third floor for bargain children's snowsuits. During the early part of the 1960s, the town offices were located here after the Abington Savings Bank fire had forced the offices to vacate the savings bank building.

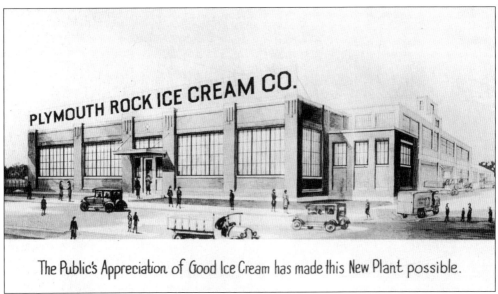

William Sheehan was the original owner of Plymouth Rock Ice Cream, a company that started out as the Plymouth Rock Candy Company c. 1915. The 194 North Avenue site was originally a carbarn built by the Rockland and Abington Street Railway Company in 1893. For many years, it was occupied by Mercury Metal Products.

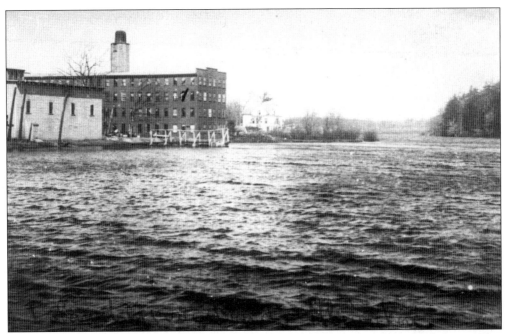

The Alden Shoe Company was located on Lake Street, along the pond of Island Grove. This view from Centre Avenue was taken before 1912, when the Memorial Bridge was built. To the left of the factory is the former power station for the railway system.

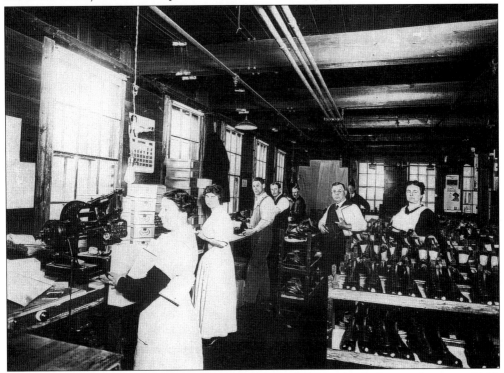

A calendar on the wall of the Alden Shoe Company pack room clearly depicts the year as 1916. The factory was nicknamed "the Klondike" because wages were paid in gold.

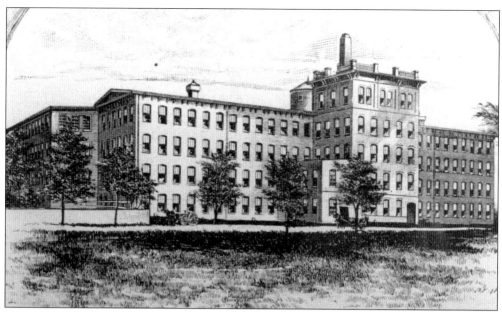

Moses N. Arnold began building his brick shoe factory in 1875. The building that held Arnold's factory still exists today on the original site at 200 Wales Street in North Abington.

This family photograph of the Arnold family was taken sometime in the early 1900s. The back of the photograph lists only four family members—William, Homer A., Moses N., and Malcolm. Moses was the Civil War soldier responsible for erecting the memorial at Island Grove.

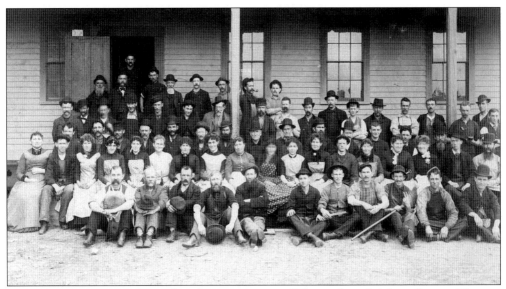

Lyons Shoe Factory was located at the intersection of Plymouth and Adams Streets. There is little data on the company. One source states that the factory may have been located at Highland Street in North Abington.

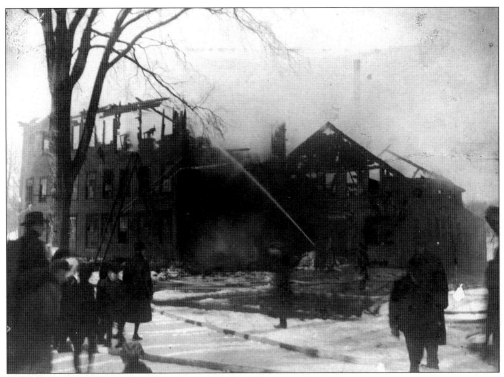

William S. O'Brien's Heel Factory stood at the intersection of Rockland Street and Brockton Avenue from 1880 to 1905. The factory employed about 75 people. On February 11, 1905, the building caught fire. Although the factory had been insured for $9,000, total damage was assessed at $12,000, and the factory was forced to close its doors after 25 years.

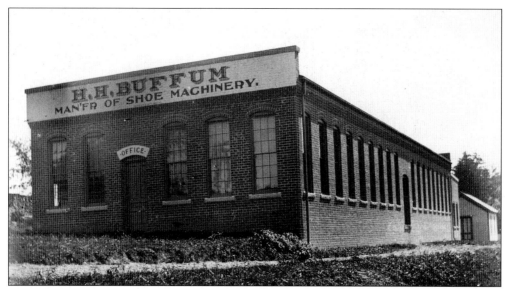

The Herbert H. Buffum Company was located at 123 Centre Avenue. Buffum moved to Abington in 1890. As an inventor, he manufactured the taffy-pulling machines at Nantasket Beach and was known for building bicycles. He also sold shoe machinery and did various mechanical repairs. In 1903, he built his first automobile. By 1906, he had perfected his ideas, and "the Buffum" was created.

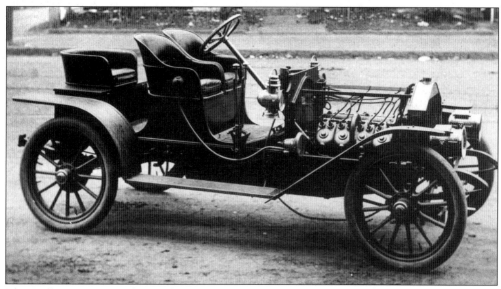

The Buffum car was made in Abington in 1905. At one time, the Buffum was considered the finest eight-cylinder car made in the United States. The H.H. Buffum Company was located where Spencer Pizza stands today on Centre Avenue.

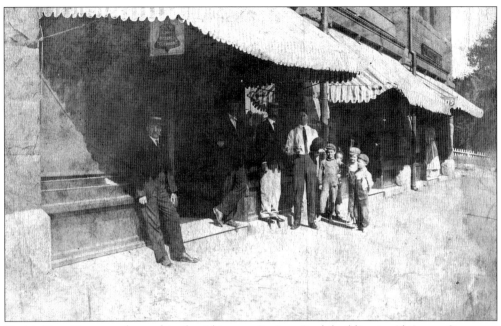

Nash's Drug Store was located in the Abington Savings Bank building in Abington Center.

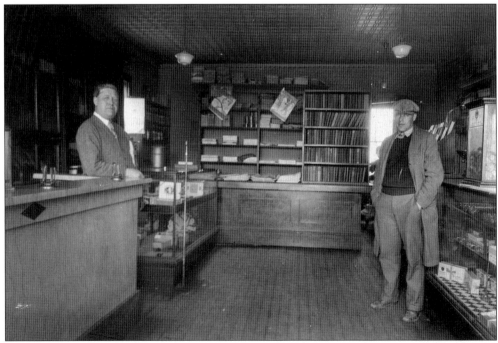

Some people still remember Erickson's store, located at the corner of Orange and Washington Streets. F.A. Erickson is shown *c.* 1920 with K. Kierstead. The store sold newspapers and penny candy.

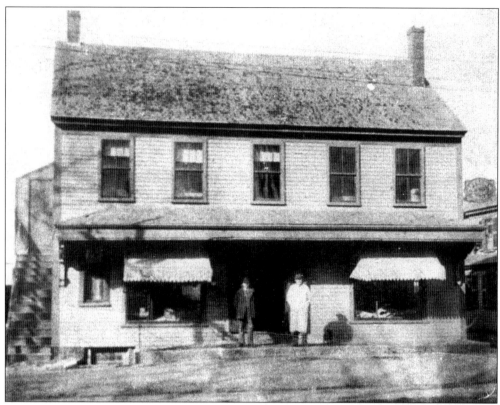

Blanchard's Market had an address of 506 Washington Street. Originally Samuel Colson's shoe factory, the house is thought to have been built in 1850 or earlier. The Blanchard family moved into the house from West Abington when they opened the store in the 1880s. It was purchased from Ed Blanchard by Gilbert L. Gates, who operated the store until the 1970s.

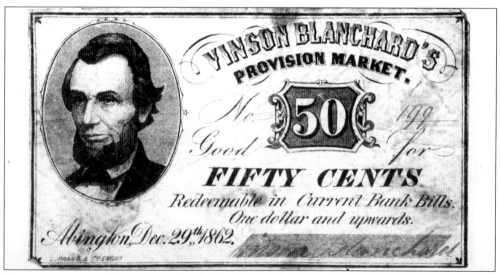

This coupon, issued during the Civil War era, is thought to have been used for rationing purposes. Note that Abraham Lincoln's face appears on the certificates.

KEENE'S HOTEL.

Electric Light and Furnace Heat.

FRED W. KEENE, PROP.

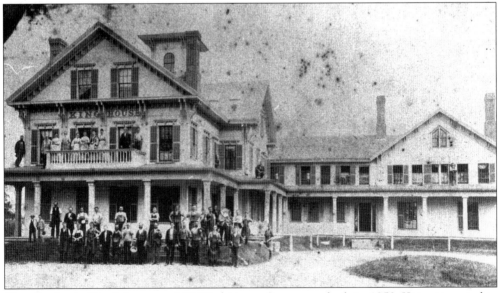

Keene's Hotel was located at the intersection of Walnut and Cherry Streets. The advertisement is thought to be from *c.* 1892. The hotel burned to the ground, and the family built another establishment at another location within Abington Center.

Gen. Benjamin King's house, at 349 Washington Street, was built in 1850. King attempted to use his influence to persuade officials that the railroad route be built along the western side of Island Grove. He believed that such a route would bring more customers to Keene's Hotel. However, the railroad was built on the eastern side of the grove. Being too far from the depot to be practical, it never prospered. In 1864, Joshua Leonard Nash purchased King's house and converted it into a shoe factory.

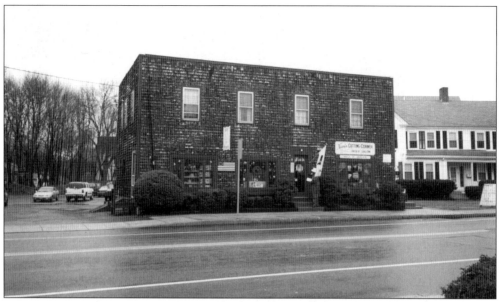

Lucius Faxon was born in West Abington. In 1860, he built a shoe factory in Abington Center. He installed Lyman Blake's sole-sewing machines and struck it rich with a contract to sell shoes to the Union army.

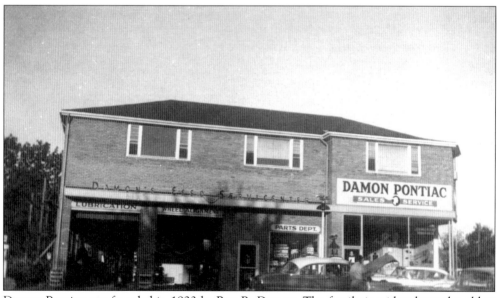

Damon Pontiac was founded in 1923 by Roy R. Damon. The family is said to have the oldest business in Abington. The business was originally located along North Avenue, but it moved in 1958 when the Bedford Street Garage was built. The steel beams of the ceiling of this building are from the Fore River Shipyard.

The Edison Electric Light Company line crew played an important role in Abington's history. Moses N. Arnold's home and factory were the first to receive electricity in Abington. Island Grove was lit in 1903.

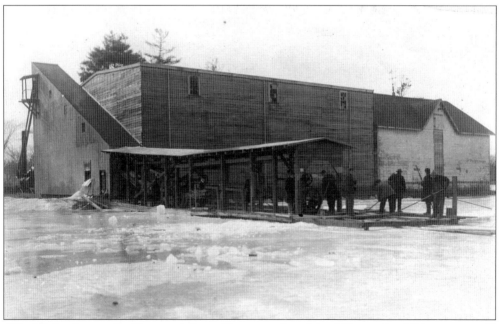

Alfred Balentine recalls, "Ice was delivered by wagon from Island Grove. As children, we would walk across the pond on the ice to watch the workers cut the ice into large pieces with a big hand saw. During warmer weather, they would spread sawdust over the ice to make the ice last." The ice was stored in icehouses, such as this one at Island Grove.

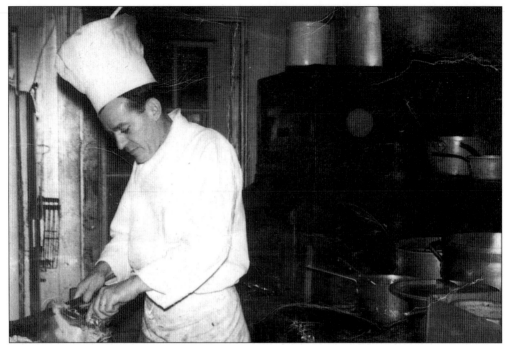

Vin & Eddie's Restaurant was established in 1954 by Vincent Travi. Vincent was the former head chef for Hugo's Lighthouse Restaurant. Located at 1400 Bedford Street, Vin & Eddie's Restaurant is a favorite among residents. Vincent bought the building in 1954, using a 1947 Plymouth as collateral.

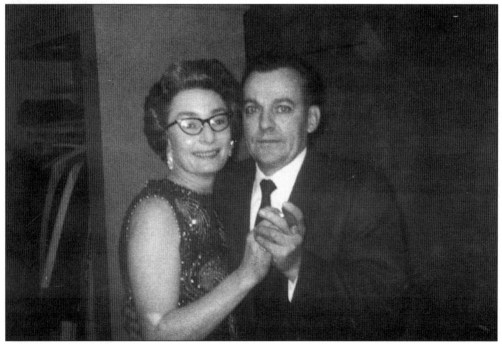

Vincent Travi and his wife, Louise, dance at their 25th anniversary in 1965. The Travi family has done many good works in Abington.

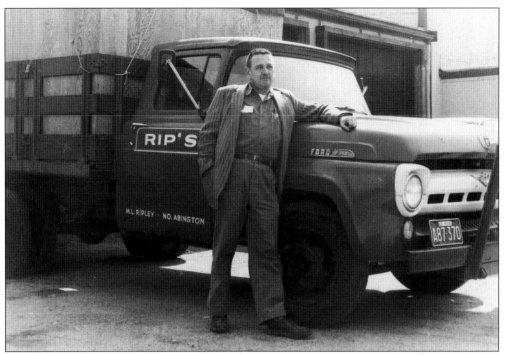

Meredith "Rip" Lincoln Ripley, shown here in 1955, began his business shortly after returning from World War II. It was incorporated in 1961. He credits his wife, Helen, with being a major part of the business.

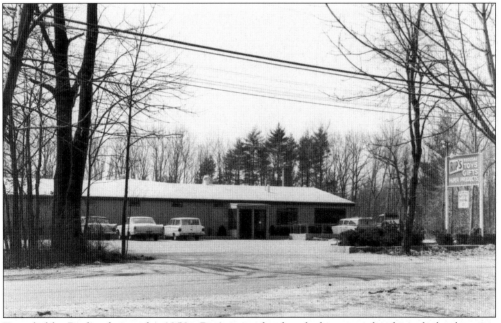

Founded by Ripley during the 1950s, Rip's was a landmark that specialized in wholesale paper goods and office, restaurant, and party supplies. Customers were known to travel to 452 Randolph Street from as far away as Maine in order to get a bargain. Ripley never advertised; he received his outstanding reputation by word of mouth.

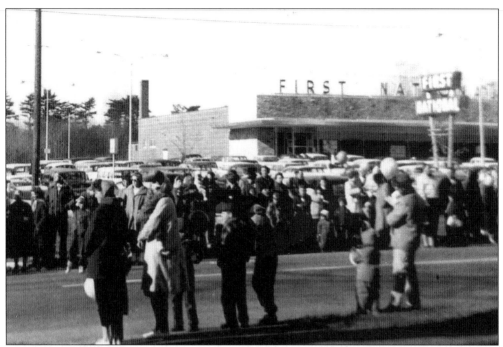

This 1962 Memorial Day parade down Bedford Street reveals a rare sight. The popular Trucchi's supermarket was once the site of the First National supermarket. Trucchi's bought the location in 1975. It was the only supermarket in town for nearly 30 years.

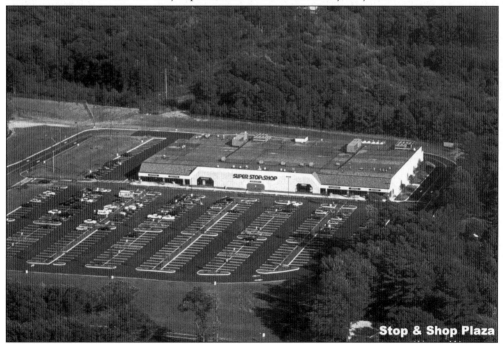

Super Stop & Shop opened in Abington in March 1995. It had formerly been located about a mile away in Rockland. The store has become a part of the community with its sponsorship of town events.

Five
COMMUNITY

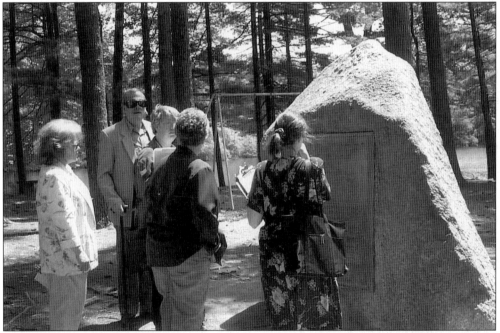

The Abington Historical Commission (AHC) was first organized in 1975. The role of the commission is to select sites worthy of the National Register of Historic Places, to establish historic districts, and to preserve the history of Abington. In this May 22, 2001 photograph, members of the Massachusetts Historical Commission (MHC) are meeting with the AHC on their first site visit to Island Grove. From left to right are Robyn B. Fernald, Walter Pulsifer III, Shary Page Berg (MHC), Barbara Aikens, and Candace Jenkins (MHC). Sharon Orcutt Peters took the photograph. Two other AHC members are not shown—Mark Alden and Phyllis Swett. Island Grove was recently named to the National Register of Historic Places.

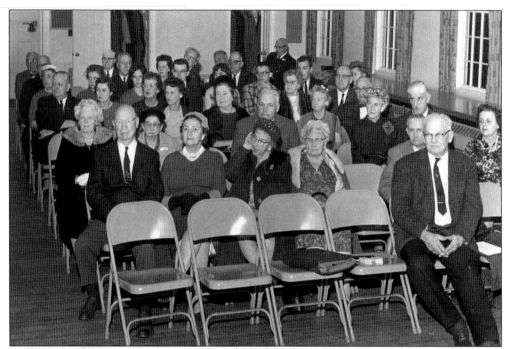

The Historical Society of Old Abington was established in 1939. It encompasses the collections of the tri-town area, which includes Whitman, Rockland, and Abington. At one time, these three towns comprised Old Abington.

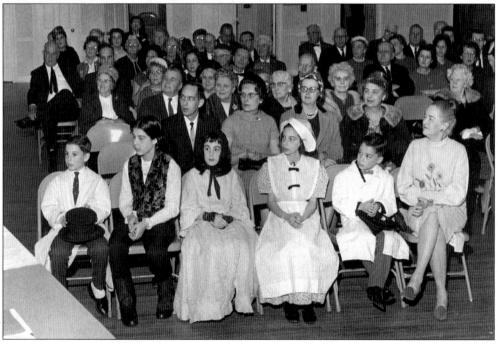

This photograph was taken in 1964 at an anniversary celebration of the Historical Society of Old Abington. In honor of the event, a play featuring Colonial days was staged by the elementary school.

After inheriting most of the Sam Dyer fortune, Marietta Dyer provided for the erection of the Dyer Memorial Library. The library, which includes artifacts from Rockland, Whitman, and Abington, houses the collections of the Historical Society of Old Abington.

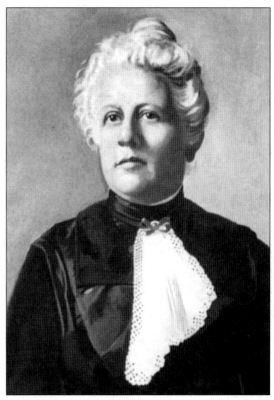

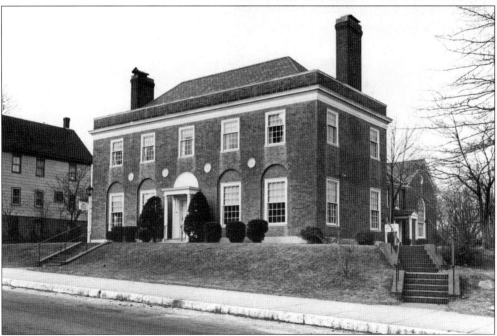

The Dyer Memorial Library is located at 123 Centre Avenue. The building encompasses three floors of artifacts and records that date back to the dawn of Old Abington's history. It also includes a collection of rare town maps and resources for genealogists.

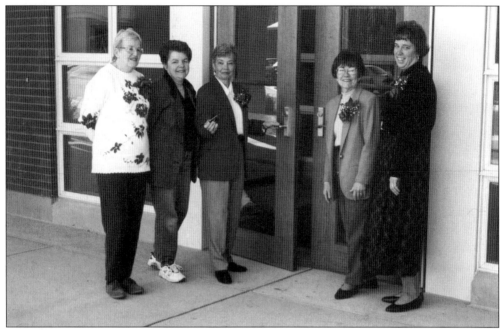

Shown at the 1997 grand opening of the new Abington Public Library are, from left to right, Helen Burgess, Nancy Reid, Jean Lothrup, Nancy Cannon, and Debra Grimmett. The children's section of the library has a outdoor garden. The Burton L. Wales Room is the meeting place for the Abington Historical Commission.

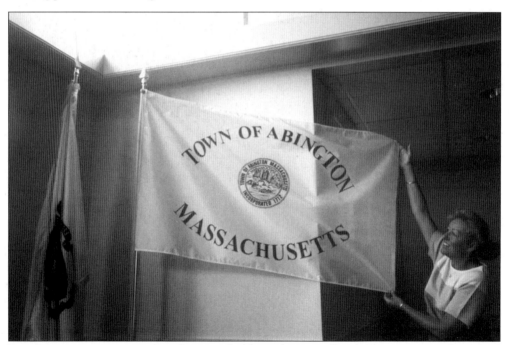

Dori Jamieson, assistant to the selectmen, holds up the new official Abington town flag. Until 1999, Abington shared its flag with Whitman and Rockland. The flag proudly hangs in the town hall, as well as the statehouse.

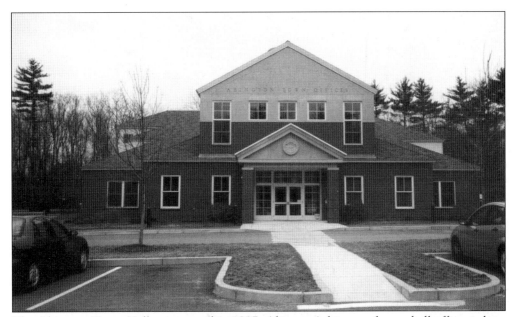

The Abington Town Hall was erected in 1997. Abington's history of town hall offices is long and varied. Until 1998, the town offices were located in the former Fourth Congregational Church on Randolph Street.

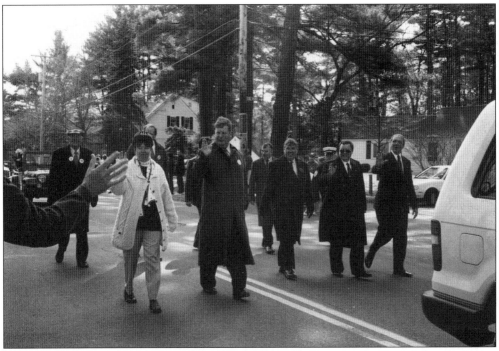

Current Abington selectmen march in the St. Patrick's Day parade. From left to right are Kathleen W. Lavin (vice chairman), Robert E. Wing, Joseph Shea, Paul Donlan, and Kevin R. Donovan (chairman). Abingtonians are traditionally interested in town politics.

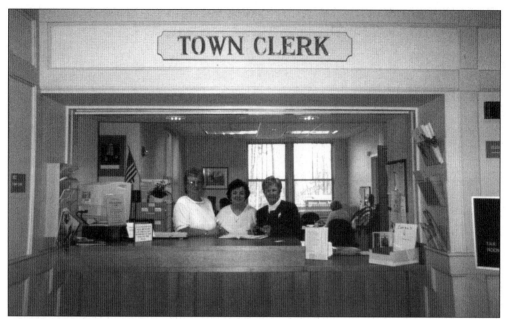

The staff in the town clerk's office is often called one of the most helpful and friendly staffs in Abington. Pictured from left to right are Pat Meredith, Linda Adams, and Patricia McKenna (town clerk).

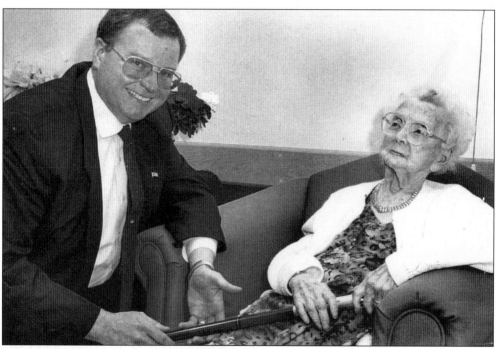

Selectman Kevin Donovan presents 105-year-old Esther Morrison with the Boston Post cane, which is awarded to the oldest resident of a town. Abington is one of a few towns to carry on the tradition, which was begun by the Boston Post newspaper in 1909. (Photograph courtesy of the Patriot Ledger newspaper.)

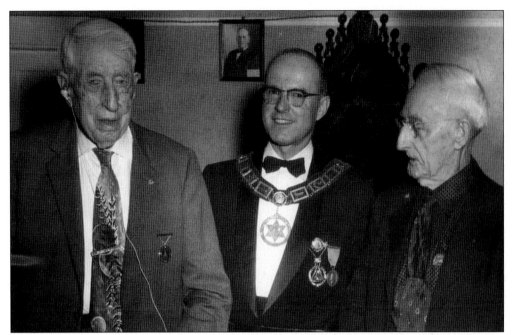

Sidney Littlefield (left) was born in 1857. When he was 100 years old, the New England Carnation Growers Association honored Littlefield with the first Sidney Littlefield Silver Award for prize carnations. In honor of his 104th birthday, the popular Quincy radio station WJDA announced Littlefield's birthday and briefly described his accomplishments, not the least of which was his attendance at the First Baptist Church in North Abington, where "a Sunday didn't go by that he wasn't in his usual seat."

Louis K. Rourke was a native of Abington. He graduated from Abington High School and went on to the Massachusetts Institute of Technology, where he graduated as a civil engineer in 1895. It was said of him, "He has been an outstanding leader in his profession because of his thorough preparation, the accuracy of his judgment, his ceaseless activity, and his high character."

As a native of Abington, William J. Coughlan (born in 1859) remained interested in his community throughout his life. He took pride in Abington's history and spent countless hours tracing the original land grants back to Plimouth Plantation. He was also a trustee of the Dyer Memorial Library. His love of Abington remained with him always; at the time of his death, he was writing a history of the town.

Robert Cotter, Esq., was born in Abington on January 26, 1920. Although he never attended college, he graduated 13th in his class from Suffolk Law School, which he attended after World War II. In 1951, he was appointed town counsel. He served in that capacity until his death in 1990. Susan Meier, chairman of the board of selectmen, said at that time, "He was a man for all times because his values never changed. He had such style." He also served on many town committees and was the president of the North Abington Cooperative Bank from 1971.

Hon. Martha Ware was an honor student during her years at Abington High School. At the age of 27, she became the first woman elected a selectman in Abington. She was also the first woman to be appointed a full-time justice in Plymouth County (1956–1979). She continues to credit her happy life to one of her father's favorite writers. A saying that her father had asked her to memorize was "The best part of a good man's life are little, nameless, unremembered acts of kindness and of love."

Following his graduation from Abington High school, Francis Murphy joined the Plymouth Rock Ice Cream Company in 1926. He served as the Abington town treasurer for 32 years and was the president of the North Abington Cooperative Bank. By all accounts, he never lost sight of the importance of community and always took pride in his home town. When he died in 1978, he left $100,000 for enjoyment by the elderly.

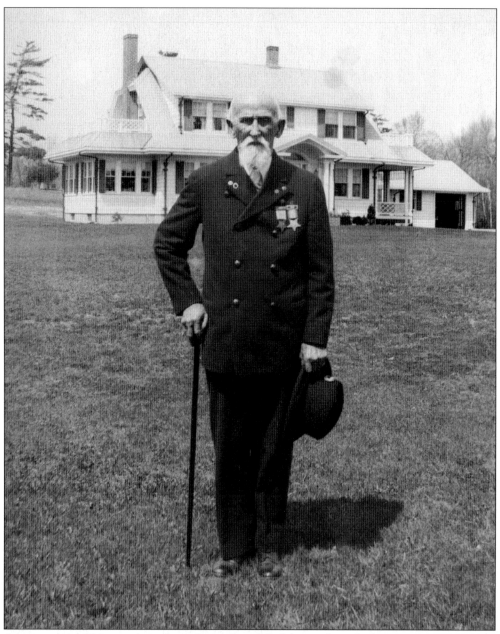

As a souvenir of his travels in the military, James B. Johnson brought home persimmon seeds. Although he had been warned that the trees would not survive the cold New England weather, he planted them anyway. Today, more than 100 years later, the fate of those persimmon seeds stands at the intersection of Washington and Adams Streets.

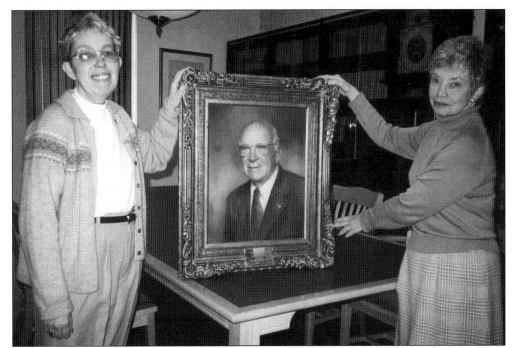

Burton Lincoln Wales is often associated with the library, as he spent 47 years as a trustee. However, few realize that Wales began his career working full time at Moses N. Arnold's shoe factory. Pictured here are Susan Durand (left) and Jean Lothrop.

Dr. George Whiting was a native of Abington for 81 years. He was one of the founding members of the Abington Historic Commission and a trustee of the Dyer Memorial Library. Whiting treated Abington patients from his home for more than 55 years and spent his life doing good works for others.

John Wheatley, the town moderator for 29 years, served as the moderator of the United Church of Christ. He was also the district attorney for Plymouth County during the 1950s. Alma Wheatley was head of the decorative committee for the newly formed United Church of Christ.

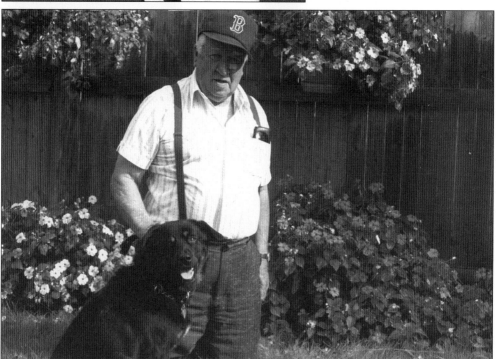

Bill Doughty, dubbed "the Mayor of Abington," and his dog Matthew Joseph were a familiar sight as they walked up and down Washington and Adams Streets. Doughty's nickname came about because of his strong interest in town affairs. He was a recipient of the Abington's Best award, given for outstanding service and dedication to the town.

John Cullen dressed each year as a leprechaun in the annual St. Patrick's Day parade. Selectman Joe Shea is seen marching in the parade in this 1995 photograph.

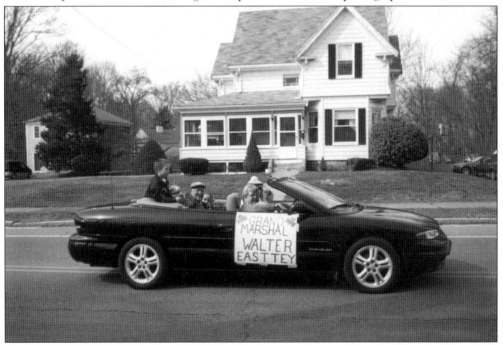

Walter Easttey has lived in Abington since 1938. Active in the Veterans of Foreign Wars, the American Legion, and the St. Vincent De Paul organization, he takes pride in being involved in his community. In this recent photograph, Easttey is grand marshal of the St. Patrick's Day parade.

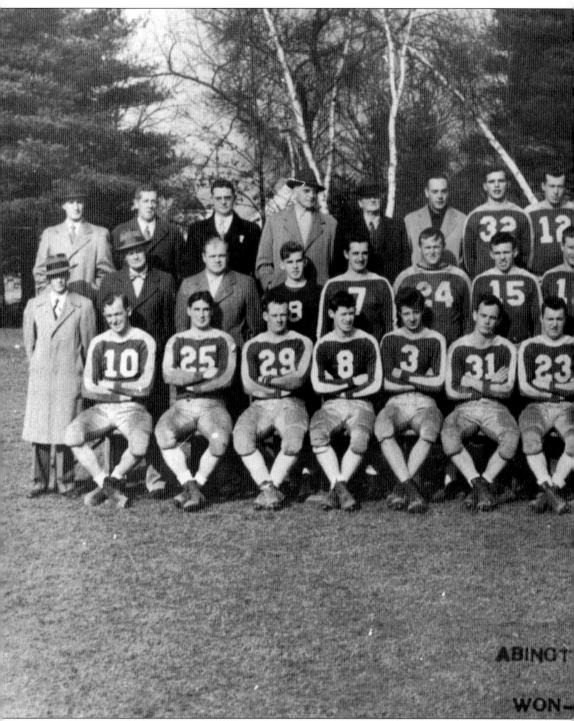

The Oldtown football team was organized in 1919 by a group of returning war veterans. The Abington Old Town Football Association commemorative booklet (1969) published this poem on the Oldtown team: "From 1919 it would seem / Here's the story of the Abington Oldtown team / We had dedication, we had organization / We had heroes, we had scrubs / We had

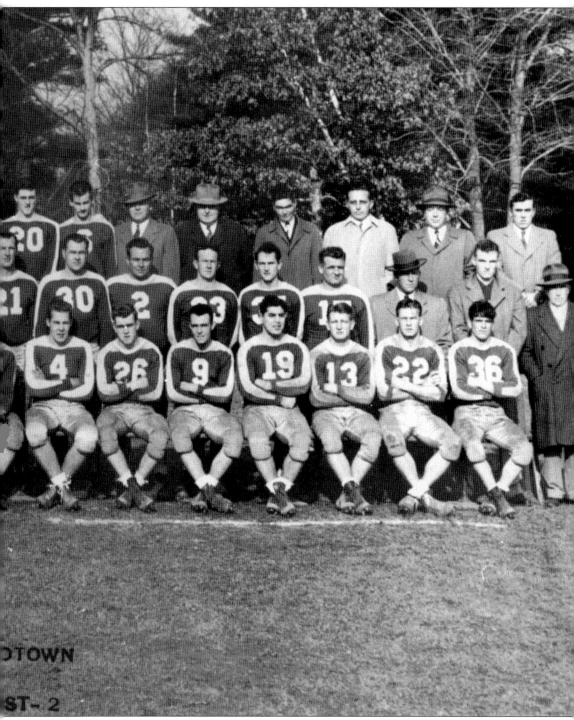

regulars, we had subs / We had management, we had fans / We had tears, we had cheers / We sampled them all / But always TOGETHER we played the game / That was the secret of Oldtown fame." —John Laucka.

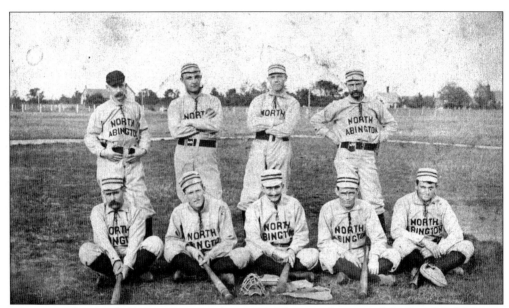

Abington's first baseball team is pictured in 1903. This was the year of the first World Series, which pitted the Red Sox (American League) against the Pirates (National League).

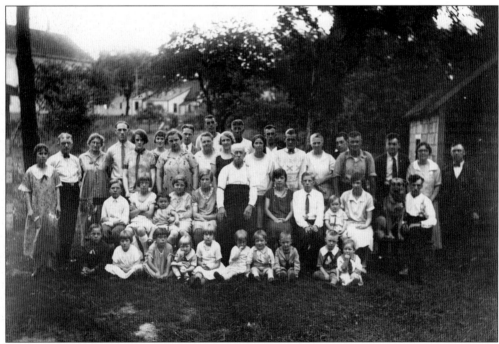

This Libby family photograph was taken on Grandpa Cobbett's 72nd birthday party in 1926. Melvin and Ruth (Calderara) Libby exemplify strong family, the essence of Abington. Both have received Abington's highest honor, the Abington's Best award.

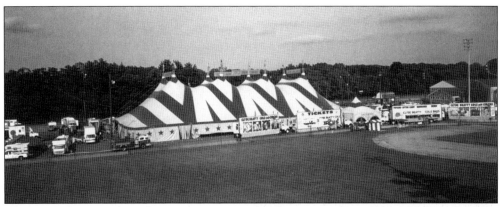

The circus first came to Abington in 1982 under the sponsorship of the Old Town Jaycees. Their sponsorship continued until 1986, when the Night Before the Fourth committee took it over as a fundraiser. It continues to this day. The circus is held each spring behind the Frolio school.

Everett Beal graduated from Abington High School in 1958 and went on to play for the Boston Pops orchestra. In this 1998 photograph, he is seen at a concert held at the new Abington Public Library.

Ann (Bailey) Reilly chairs the Pride of Abington program, also known as Adopt-an-Island. She founded the Busy Beaver store in 1980 and began the Abington House Tours in the early 1990s.

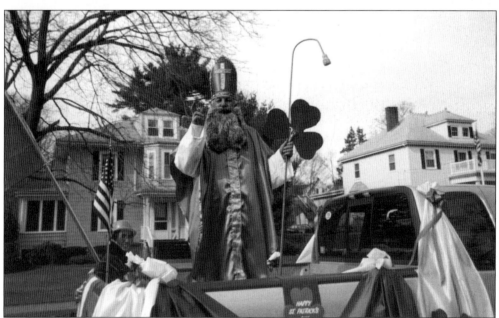

Jack Bailey began the annual St. Patrick's Day parade, now in its 23rd year. The parade took root from a $10 bet that Bailey could not begin the annual tradition. It has fast become one of the largest parades on the South Shore. As part of the event, Bailey dresses as St. Patrick himself.

Six
ISLAND GROVE

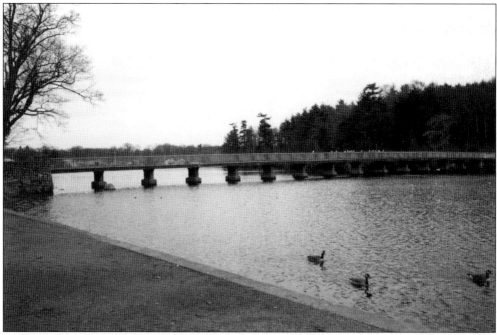

Island Grove is often called Abington's crown jewel. This 35-acre park has been the site of historic events and has provided many recreational memories for those who lived during the early part of the century. The pond was created by flooding Ford's Meadow with a dam at Central Street. The bridge and arch were erected in 1912 for the bicentennial celebration of the town. The park is listed on the National Register of Historic Places.

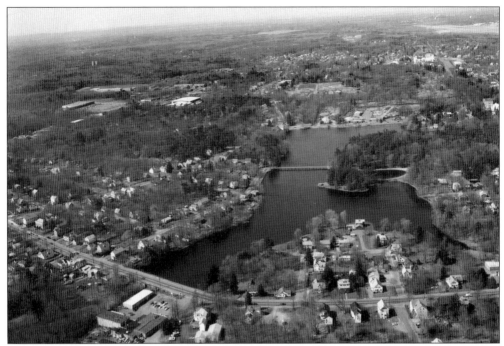

This aerial view of Island Grove and surrounding areas shows the old Glad Tidings Church (far left) and the Dyer Memorial Library (across the street). The park department is directly across the pond. The Memorial Bridge is 300 feet long. The western end of the bridge connects Wilson Street to Island Grove.

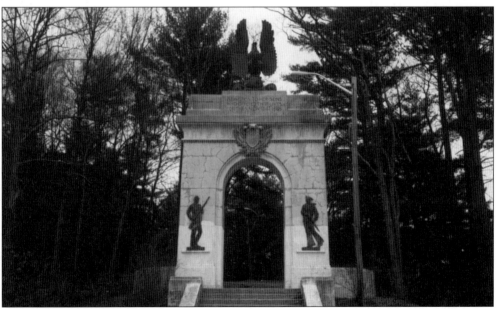

Life-sized bronze figures of a Civil War soldier and sailor adorn the Memorial Arch. It was erected in 1912 during the bicentennial celebration. The 11-foot bronze eagle was designed by Bela Lyon Pratt, who is also responsible for the sculpture outside the Boston Public Library.

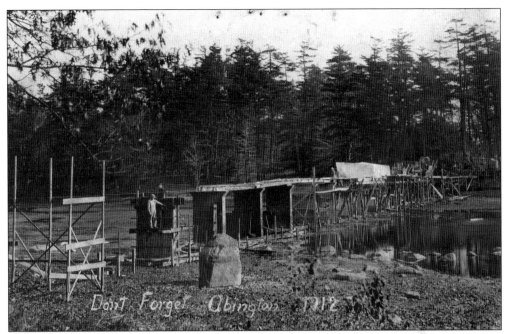

This rare photograph captures the construction of the Island Grove Bridge. The postcard reads, "Don't forget Abington, 1912." The Memorial Arch is not yet erected in the photograph. Due to the drained pond, Lighthouse Rock is in full view.

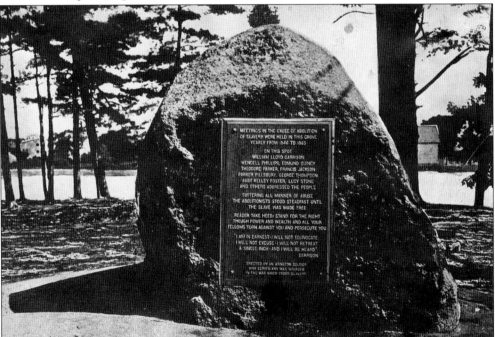

The Abolishionist Monument is placed where the speaker's stand once stood at Island Grove. Many famous abolitionist speakers spoke against slavery at Island Grove, such as William Lloyd Garrison, Wendell Phillips, and George Thompson. The monument was erected by Moses N. Arnold, Abington shoe manufacturer and Civil War veteran.

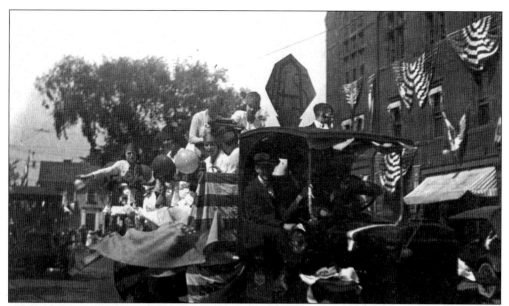

Abington was incorporated in 1712. In honor of its 200th year, a parade made its way down Centre Avenue and into the Park Street entrance of Island Grove. Buildings were draped in red, white, and blue for the bicentennial celebration.

The Coughlan family celebrates the bicentennial in this photograph. Daniel R. Coughlan, general chairman in 1912, is wearing the silk top hat. In the sailor hat is his nephew William D. Coughlan.

Although most people consider Lake Street to be the main entrance to Island Grove, it was traditionally Park Street. The Lyceum Hall and railroad platform were located at this end of the park, making an easier walk for Abington visitors.

Island Grove, View through the Pines, Abington, Mass. 9233

This c. 1912 view shows families strolling through the grove along the walking path. The trees shown in this image are the original pines, elms, and oaks that were natural to the grove during this time. The 1938 hurricane forced numerous replantings of pine trees.

A 1915 view of a Centre Avenue stroll depicts the quiet street that is lined with elm trees, a place where lovers often strolled. Today, most of the elms are gone. Across the street from this scene and under the road bridge are the remains of the dam that was used to flood the grove in order to make the millpond.

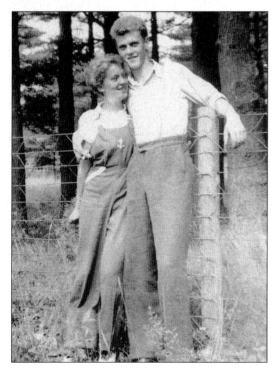

Alfred Balentine lived across the street from Island Grove. During the summer of 1936, Balentine was taken with a pretty young girl swimming at Island Grove. Balentine and Sarah Kohler fell in love, and the rest is history. The Balentines were one of many couples who met and then married at Island Grove. At one time, the park flourished with canoes and was the site of lively band concerts.

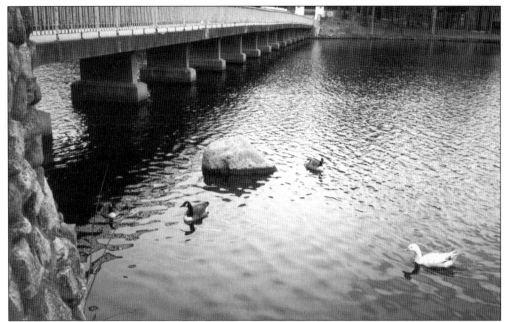

Lighthouse Rock has two drill holes. The first was drilled before 1750, when James Nash and Andrew Ford erected the first mill. The second was bored into the rock in 1846, when more power was needed for the mills. The holes were used as flood markers by the mills that once surrounded the pond. It is thought that the shape of the rock and possibly its proximity to shore led to the name Lighthouse Rock.

George Whiting reads the *Liberator* during an exhibit featuring Island Grove. The photograph was taken in the 1960s. Island Grove is best known as host for many famous abolitionist speakers. William Lloyd Garrison, editor of the *Liberator*, often wrote about meetings held at the grove.

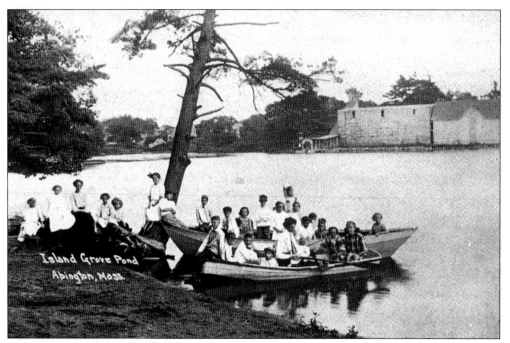

The back of this postcard says it all: "Here is where I went yesterday. Crossed the Memorial Bridge into the grove. Went to the cemetery. Two hundred years old. Could not hear any of the speaking. Such a crowd. Could hear the band."

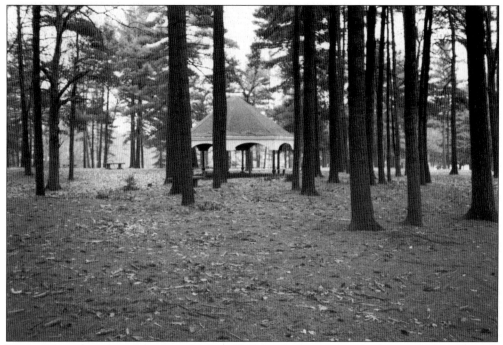

The gazebo is thought to have been built in 1912 for the bicentennial celebration. It still stands today and is used often by those who picnic at the grove. It is guessed that some of the beams in the gazebo were replaced in the 1940s.

Nancy Reid (left) and Susan Meier fill sandbags at Island Grove to weigh down candles for a candlelight celebration at Island Grove. Susan Meier was the second female selectman to be elected in Abington. Nancy Reid is well known for her community work and library assistance.

Kate Ford and her fiancé, Tomas Revesz, visit the Abington Historical Commission in September 2001. The commission hosted a tour of Island Grove at that time. Ford is on the board of the Abington Foundation and is a descendant of Andrew Ford, founder of Abington.

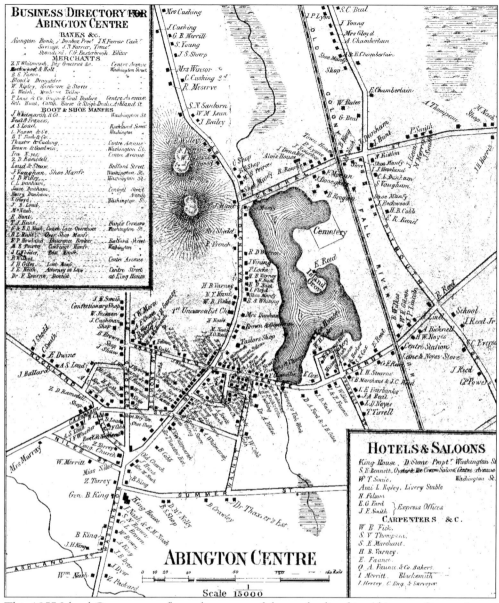

This 1857 Island Grove map reflects the names of those who lived in Abington Center. It was customary in earlier days to recognize an area by the names of the people living there.

Seven
SCHOOL

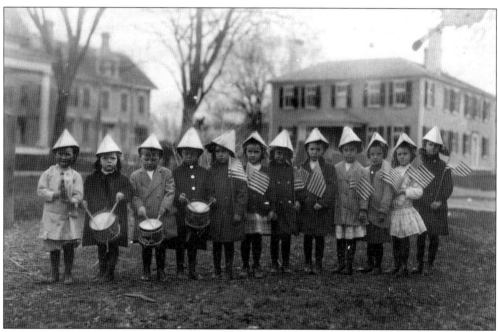

The 1910 Abington kindergarten class attended school on Dunbar Street in Abington Center.
These students are dressed patriotically to celebrate a Memorial Day event.

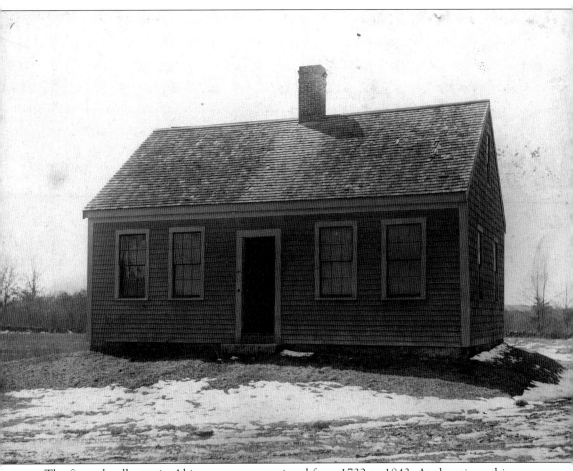

The first schoolhouse in Abington was operational from 1732 to 1843. At that time, this one-room schoolhouse served the entire town of Abington, an area that stretched around Accord Pond to the east, to the Brockton line to the west, and as far south as the Whitman-Hanson town line. Schools of these times had few, if any, amenities. Outhouses existed behind the schoolhouse, and water was drawn from a well. The school was located near the meetinghouse at Summer and Washington Streets.

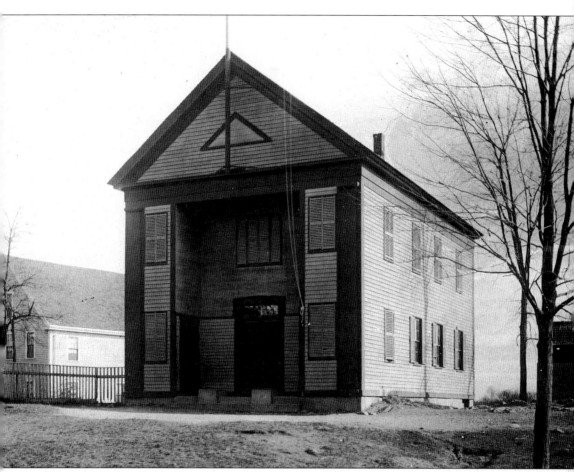

Abington Union Academy was opened in 1843 near the intersection of Summer and Washington Streets. For a short time in 1849, it was used as a high school.

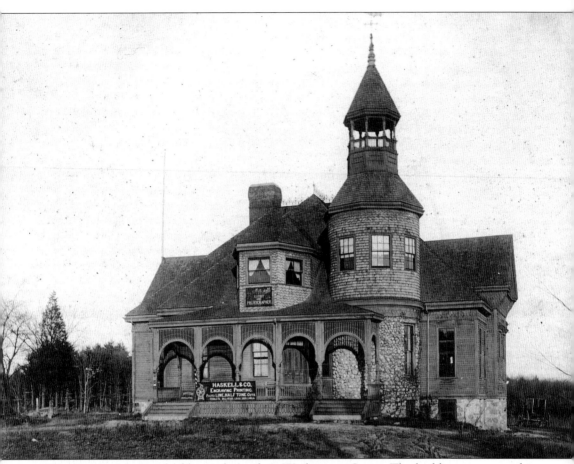

The American Legion building is located on Washington Street. The building was erected in 1853. It was the first official high school (1890–1902). There were 14 students in the first graduating class, 9 of whom were expected to go on to become teachers.

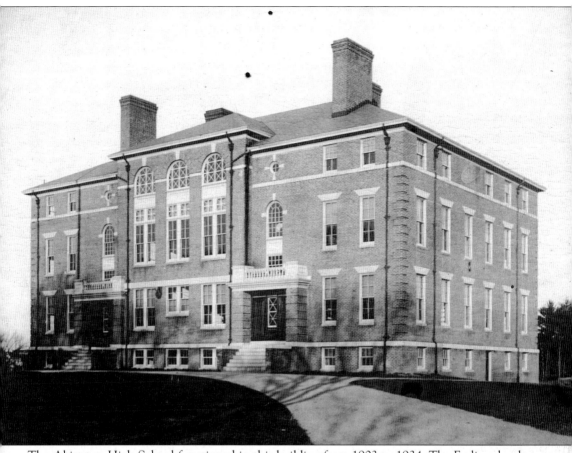

The Abington High School functioned in this building from 1903 to 1934. The Frolio school stands on this site today. The two schools look very much alike.

This photograph of a 1917 school sleigh was a gift from Mr. and Mrs. Albert Beal in 1985. Albert Beal recalls that the sleigh would carry the children of West Abington to the Dunbar Street School in Abington Center. The sleigh carried about 25 children to and from school, an hour's travel each way.

From 1849 to 1851, William A. Stone was Abington's first school principal.

This photograph of the Abington High School Class of 1895 includes, from left to right, the following: (front row) Emma McKinney, Annie Rand (visitor), Inez Shaw, Agnes Donahue (guest), Minnie Donahue, Archie Nelson, Leroy Hunt, Grace Reed, and Gertrude Gaffney; (back row) Edward Carey (standing), Mary Buckley, unidentified, Lucy Arnold, and Carlton Reed.

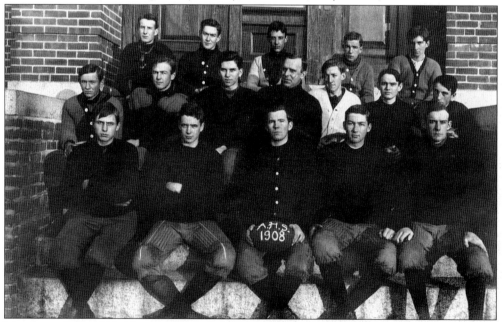

Members of the 1908 Abington High School football team are, from left to right, as follows: (front row) Ralph Allen, Burton Wales, Bennett Turner, Howard Torrey, and Clarence Brett; (middle row) Raphael McKeown, Richard Wyman, George Wheatley, Henry Blake, (principal), George Mansfield, Frank Gunn, and Edwin Crowley; (back row) Guy Bishop, Grover Mylott, Stanley Dwyer, Fred Donovan, and John Murphy.

The Abington High School was built on Washington Street in 1903. However, the school would only be in use for 30 years before a fire in December 1934 almost destroyed the building. It was torn down in the spring of 1936. The high school was rebuilt in the same location, where the Charles M. Frolio Junior High School stands today. For the four years prior to 1970, Massasoit Community College used the building as an interim school.

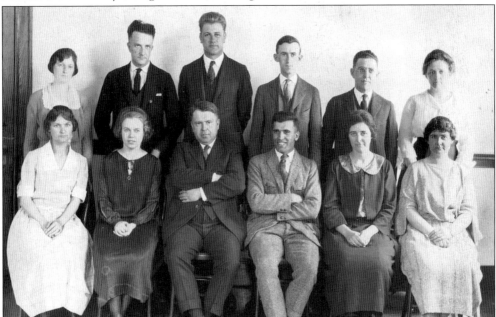

The members of the 1924 school faculty are, from left to right, as follows: (front row) unidentified, unidentified, Elijah Day Cole, Charles M. Frolio, Alice Gorman, and Ruth Webster (art teacher); (back row) unidentified, unidentified, ? Lindahl, Joseph M. Murphy, unidentified, and Annie Chadbourne.

96

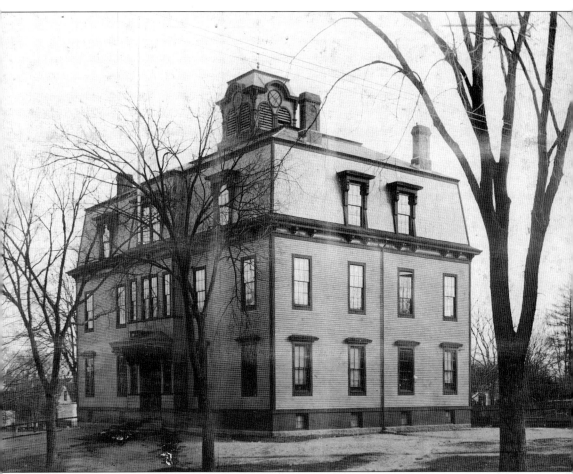

Between 1873 and 1938, the children of Abington attended this three-story schoolhouse, located at 66 Dunbar Street. The building later became a frozen-food locker, which eventually closed due to the increasing availability of freezers. In 1972, an apartment complex was built on the site.

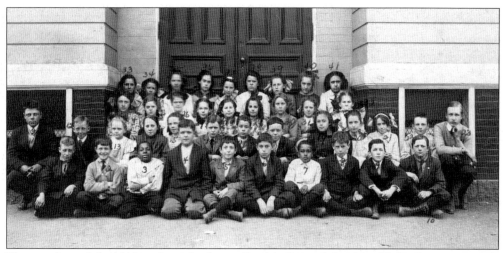

The members of the 1912 sixth-grade class at Dunbar Street School are Philip Pennington (1), Gilman Peavey (2), Harold Cornwall (3), Frank Nickerson (4), Philip Baron (5), Leslie Garfield (6), Walter Cornwall (7), Albert Collyer (8), Lewis Donovan (9), Floyd Burrell (10), Burton Simmons (11), Joseph Slattery (12), Margaret Robbins (13), Margaret Devlin (14), Helen Burns (15), Philip Blanchard (16), Henry Mylott (17), James Russell (18), Ruth Kierstead (19), Louise Cody (20), Doris Colburn (21), Donald Strachan (22), Norman Pike (23), Alice Whitman (24), Hazel Taylor (25), Nora McEnelly (26), Hilda Crowley (27), Miriam Ford (28), Clara Stetson (29), Helen Baker (30), Irene Powers (31), Eleanor Surdam (32), Velma Lydon (33), Lucy Burrell (34), Rosalie St. Charles (35), Florence Vining (36), Mae Guild (37), Antoinette Martin (38), Elizabeth Ellis (39), Gladys Matheson (40), Gabrielle Menard (41).

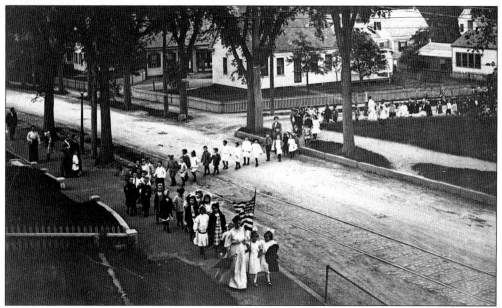

Following the lead of their teacher, these Dunbar Street schoolchildren cross Centre Avenue on their way to exercises held in Franklin Hall. Franklin Hall was located on the first floor of the Abington Savings Bank building in Abington Center. Dunbar Street student Mary Dalton recalls that the maypole was located at Franklin Hall.

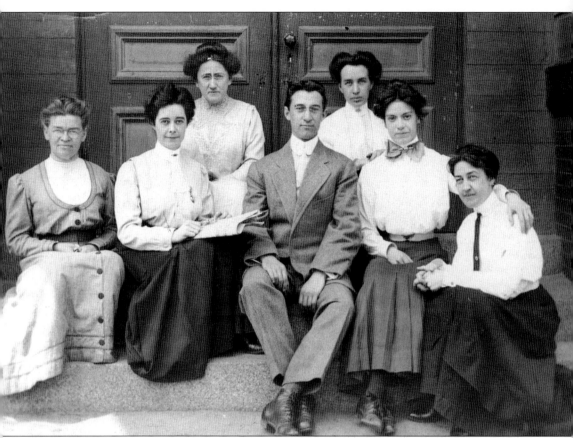

Teachers at Dunbar Street School in 1918 are, from left to right, Julia C. Morton, A. Clare Crowley, Lucy J. Kenney, C. Arthur Wheeler (principal), Harriett Jeffers, Lillian Fitzgerald, and Louise Hill.

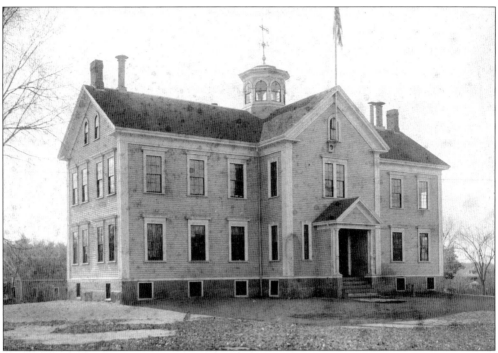

The Adams Street School is located at the intersection of Plymouth and Adams Streets. The school grounds were purchased by the town for about $500, a steep price for 1889–1890.

In 1940, the Adams Street School changed its name to the North Elementary School, the name it still uses today.

Charles Frahar, principal of the Adams Street School, is still remembered and loved by townsfolk. He was a town historian in his own right, taking the opportunity to teach children about the town every chance he got.

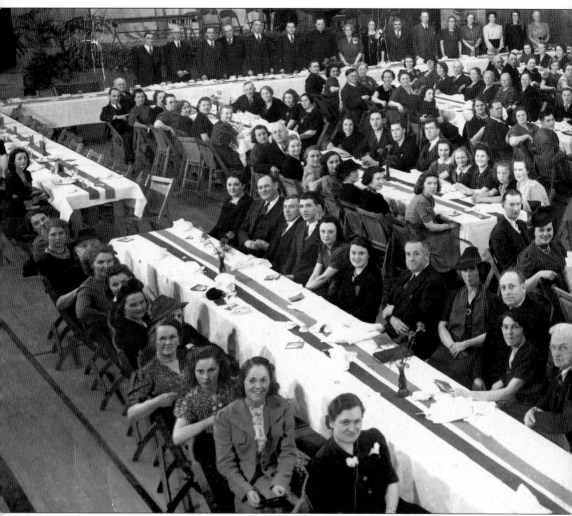

Kate Kelley tells this story: "On February 14, 1940, as students in the North Elementary School prepared cards for their beloved principal, Charles Frahar's party that night, snowflakes continually spit against the school windows. That night, as it continued to snow, people gathered at the Frolio school to honor Frahar for his many years of service to the schools. When

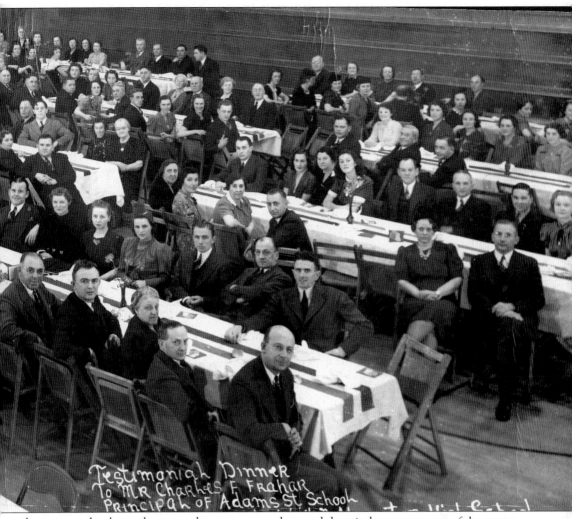

Testimonial Dinner to Mr Charles F Frahar Principal of Adams St School

they prepared to leave the party, the snow was so deep and the wind so strong most of the guests went back inside the school where they spent the night singing, putting on a show, and cooking breakfast in the school cafeteria. They had such a good time that for many years they held reunions on the anniversary of the Valentine's blizzard."

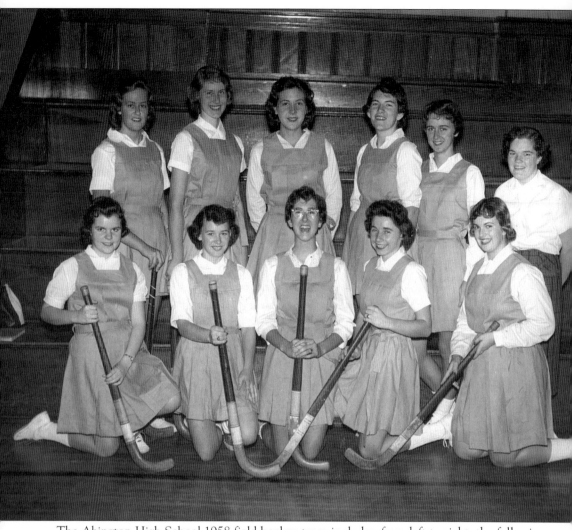

The Abington High School 1958 field hockey team includes, from left to right, the following: (front row) Nancy Damon, Barbara Bowser, Sue Williamson, Jackie Page, and Marilyn Polson; (back row) Connie Piho, Evelyn Kristianson, Beth Stone, Margeret Kelliher, Barbara Page, and Carol Bienvenue.

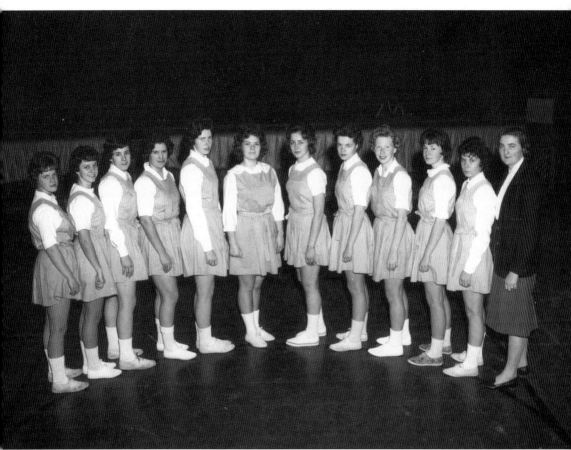

This photograph shows the 1962 Abington High School girls' varsity basketball team. From left to right are M. McDonough, L. Ashton, C. Manson, J. Morse, M. Gannon, N. Jefferson, J. Bulkowski, L. Price, D. Johnstone, J. Leach, D. Furse, and Marcia Crooks.

A 1958 spring dance at the high school shows a glimpse of the days of chaperones. Adults who attended often sat separately across the room from those they had escorted. It was a big year—it was the first time that students were allowed to decorate the gym with lowered streamers for ambiance.

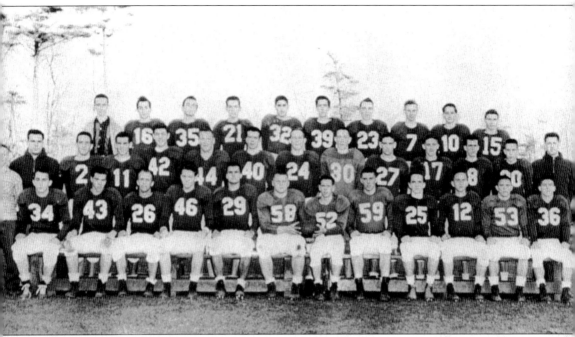

The 1956 Abington High School football team won the Southeastern Conference championship. In 2002, the high school team won the Eastern Massachusetts Division 5 championship.

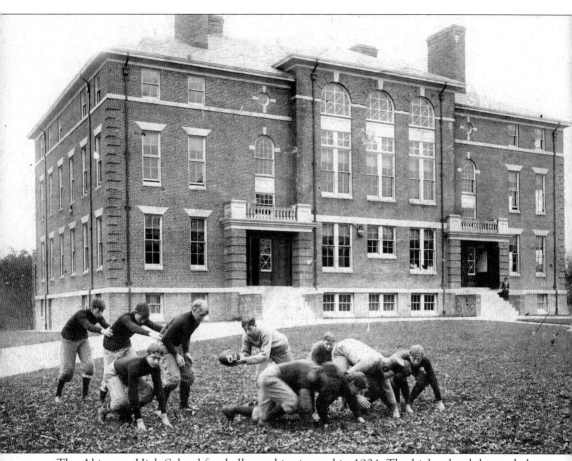

The Abington High School football squad is pictured in 1904. The high school, located along Washington Street, stood where the Frolio school is today.

In 1910, Abington High School put on a play entitled *Mr. Easyman's Niece*. Pictured from left to right are the following: (front row) Alice Hurlett, Florence Garrity, Ruth Wilkes, and Louise Merrill; (back row) Richard Wyman, Harry Cook, George Wheatley, H. Bennett, and Paul Newcomb.

This old school desk and chairs were most likely from the Pine Woods school that was temporarily established as a high school in 1852. The school was located at 734 Plymouth Street.

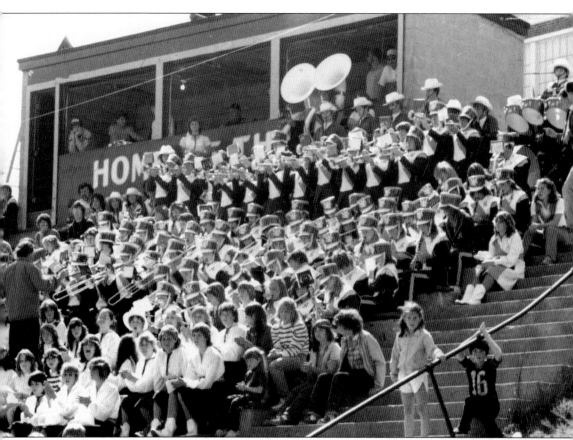

The Abington High School Band plays in the bleachers behind the Frolio school at a home game in 1982. "The Green Wave" played Rockland, their school rival.

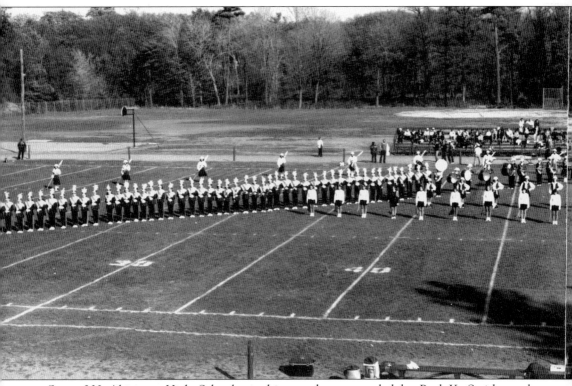

Some 200 Abington High School marching students were led by Paul K. Smith to the

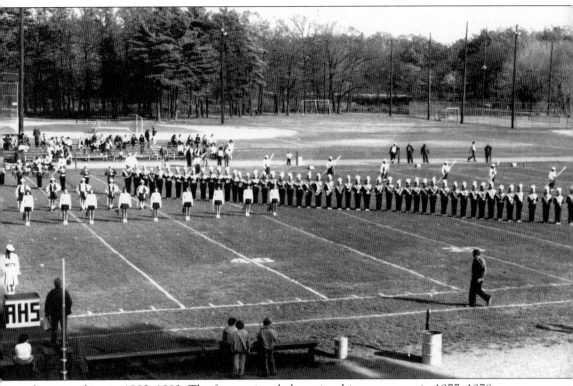

championships in 1982–1983. The first national championships were won in 1977–1978.

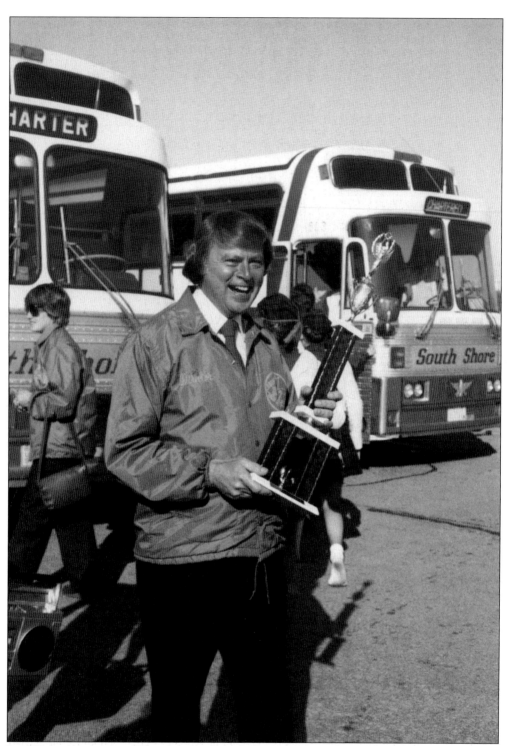

Paul K. Smith came to Abington in 1957 and directed the students for more than 30 years. He was called "Abington's music man." By all accounts, he was energetic and enthusiastic, and he inspired the school to become known as the marching champs during the late 1970s and 1980s.

Pictured is Thomas Graham, beloved history teacher at Abington High School for more than 30 years. He began teaching at Abington High School in 1965. He was originally hired as a mathematics teacher but soon became known as one of Abington's finest history teachers. He was also head baseball coach from 1976 to 2001.

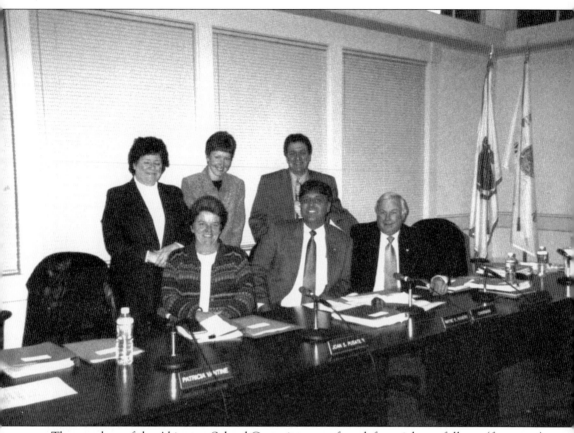

The members of the Abington School Committee are, from left to right, as follows: (front row) Patricia Vantine, Wayne Rogiers, and Dr. John Aherne (superintendent of schools); (back row) Joan Pusateri, Brenda Pignone, and Russell Fitzgerald.

Eight

MILITARY, FIRE, AND POLICE

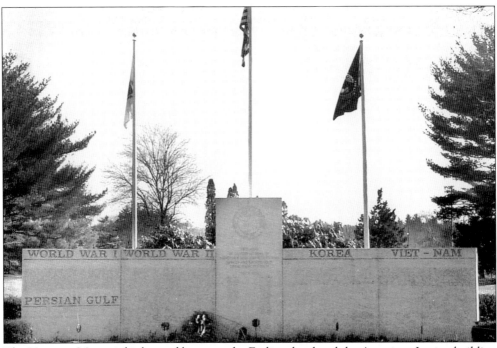

The Veterans Memorial is located between the Frolio school and the American Legion building on Washington Street. The monument is dedicated to Abington veterans who served in World War I, World War II, Korea, Vietnam, and the Persian Gulf.

Dr. Joseph A. Valatka began his medical career in Abington in 1944. In 1953–1954, he served in the medical corps in Korea, where he was promoted to major.

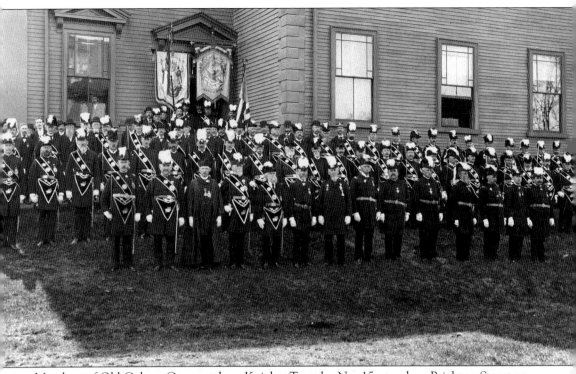

Members of Old Colony Commandery, Knights Templar No. 15, stand on Brighton Street on April 20, 1896.

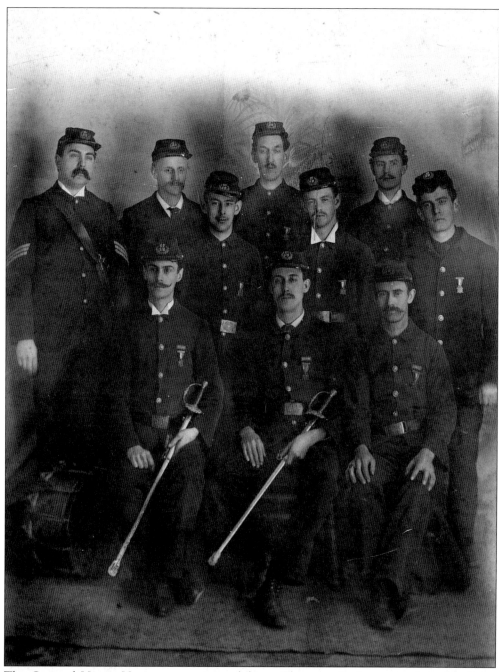

The Sons of Union Veterans are pictured here. The organization recognizes the direct descendants of those who served in the Civil War.

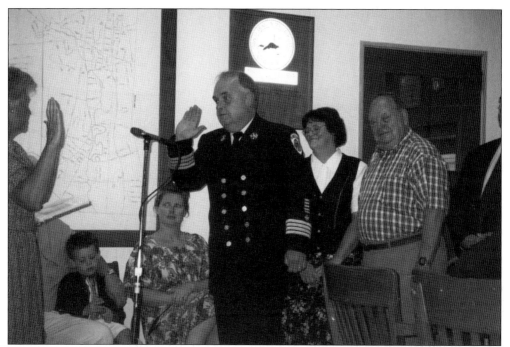

Malcolm B. Whiting is sworn in as Abington fire chief in August 1997. His father, Dr. George L. Whiting, and his wife, Pamela Whiting, proudly look on. Pat McKenna swore the fire chief into office.

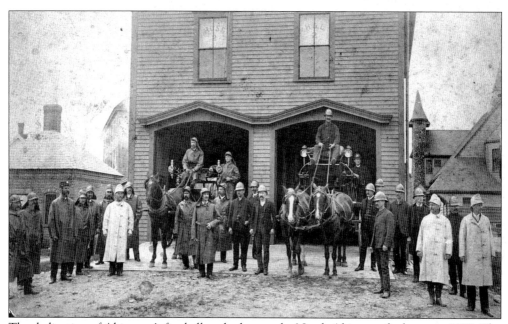

The dedication of Abington's fire bell took place at the North Abington firehouse in 1880. The fire bell was recast from an original bell that hung in Faneuil Hall in Boston. The 1,100-pound bell is now at the Dyer Memorial Library. The smaller bell, weighing 400 pounds, is now on the front lawn of the fire station on Bedford Street.

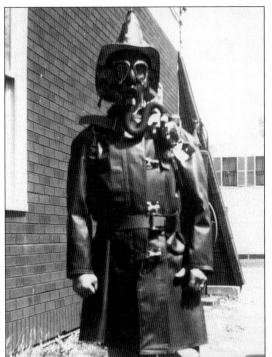

A gift from Madeline Stone, this photograph was found at the Dyer Memorial Library. The back reads, "Year 1947–48. This possibly is Carl Shaw. It is one of the first (Scott AirPaks) which was a self contained air mask bought by the Fire Department."

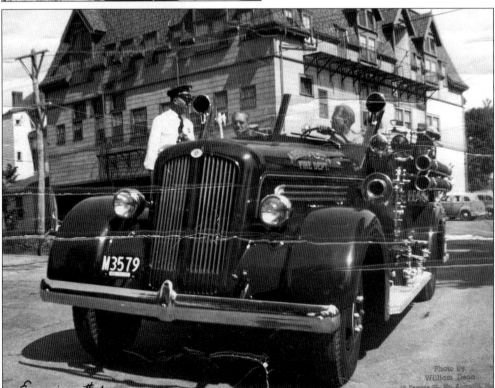

A July 2, 1948 photograph in front of the North Abington firehouse shows Chief of Police John Litchfield (standing), Ted Freeman (sitting), and Capt. Carl Shaw (at wheel).

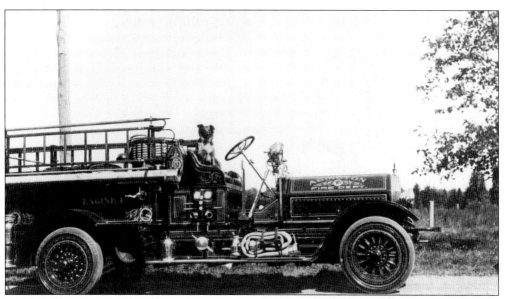

Teddy belonged to Carl S. Shaw, Abington's only permanent fireman for many years. He sits atop a 1912 fire engine.

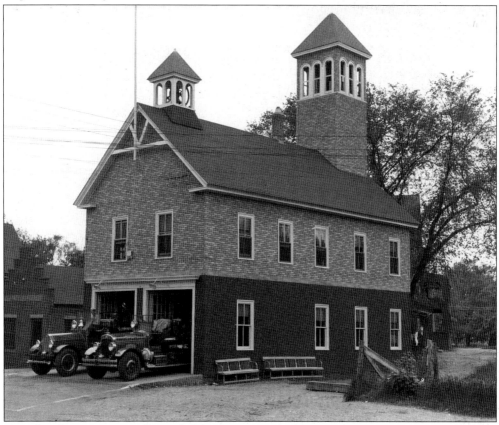

New shingles were put on the roof of the fire station building in 1945. The small brick building to the left of the fire station was the location of the Abington Police Department.

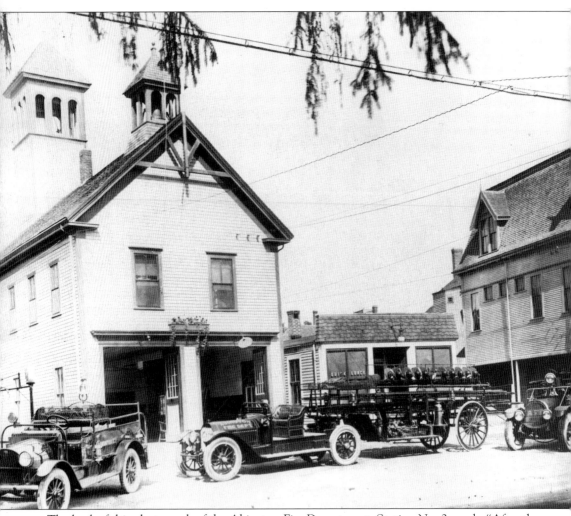

The back of this photograph of the Abington Fire Department, Station No. 2, reads, "After the car barn fire, 1920." To the left is the Standish Block. The towers of the Brighton Street station once held two firehouse bells. The bells were removed from the station in 1965. The smaller bell would serve as a memorial at the newer fire station on Bedford Street.

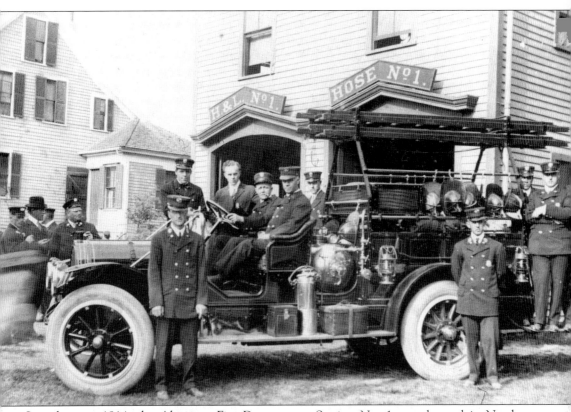

Seen here in 1914, the Abington Fire Department, Station No. 1, was located in North Abington Center for many years. The new station is on Bedford Street.

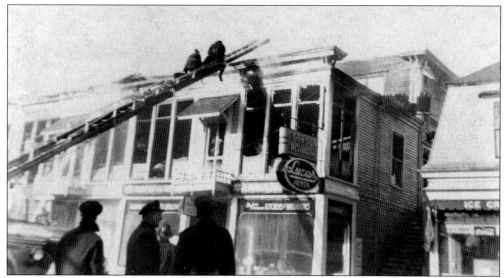

Since the building was taken by fire in 1952, few photographs can be found of the Dobson building. The area is now recognizable as a piece of land that still exists along North Avenue, between Mike and Dave's Barbershop and Morrell's Country Kitchen restaurant.

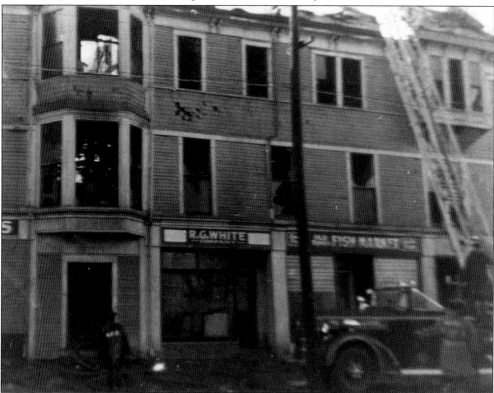

Michael "Red" Resevic began his business, Dobson Distributors, in 1947. He named his company for Joe Dobson, the Red Sox pitcher who had pitched a winning game the night before the company was incorporated. After the fire on North Avenue, the business relocated to its present-day location on Brockton Avenue.

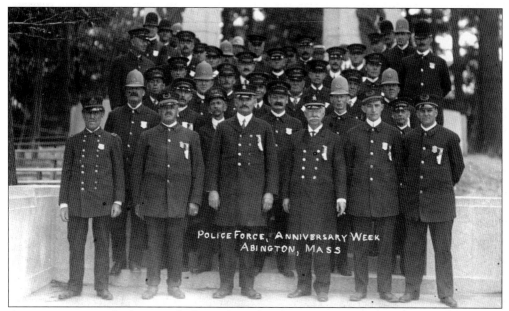

An anniversary week photograph shows the police force c. 1900. John F. Hollis was the chief of police at the time. The Memorial Arch at Island Grove is visible in the background.

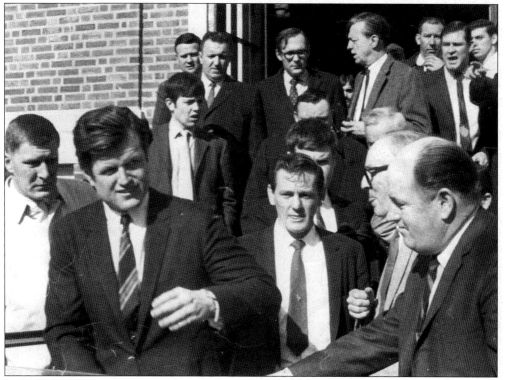

In 1969, Ted Kennedy gave a talk to students at what was then Massasoit College, now named Frolio. He is shown being escorted to his car by the Abington Police Department. To the left of Kennedy is Det. Fran Johnson. Chief J. Edward Murphy is at the upper left, and to the right is Tom Bowden.

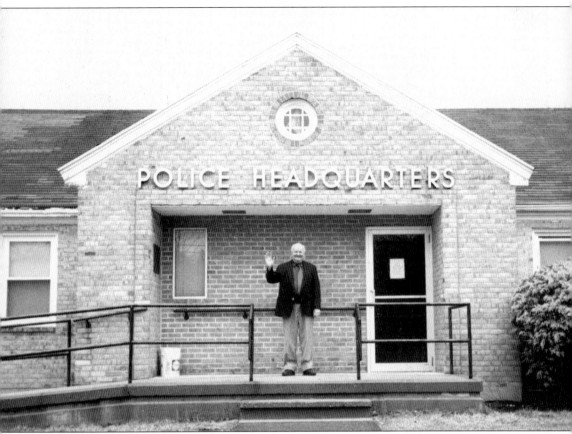

Chief Richard L. Franey waves from outside the police headquarters on Central Street. The new station was built after a 1964 annual town meeting and is located very near to the original jail, which was in the old Lyceum Hall, near St. Bridget's.